LOS ANGELES RESIDENTIAL ARCHITECTURE

LOS ANGELES RESIDENTIAL ARCHITECTURE
MODERNISM MEETS ECLECTICISM

RUTH WALLACH

THE History PRESS

Published by The History Press
Charleston, SC 29403
www.historypress.net

Copyright © 2015 by Ruth Wallach
All rights reserved

First published 2015

Manufactured in the United States

ISBN 978.1.62619.803.6

Library of Congress Control Number: 2015944403

Notice: The information in this book is true and complete to the best of our knowledge. It is offered without guarantee on the part of the author or The History Press. The author and The History Press disclaim all liability in connection with the use of this book.

All rights reserved. No part of this book may be reproduced or transmitted in any form whatsoever without prior written permission from the publisher except in the case of brief quotations embodied in critical articles and reviews.

CONTENTS

Acknowledgements	7
Introduction	9
PART I. ARCHITECTURAL AND HOUSING EXHIBITIONS	17
Architects' Building Material Exhibit	22
California House and Garden Exhibition	24
Post War House	32
Annual Home Shows	40
PART II. NEW SUBDIVISIONS AS PURVEYORS OF ARCHITECTURAL TASTE	55
New Windsor Square and Adobe Electric House	56
Los Angeles Times Demonstration and Prize Homes	58
Home Exhibitions in Leimert Park	65
PART III. MASS HOUSING, HOUSING THE MASSES	83
Apartment Building Styles	86
Garden Apartments and Architectural Modernism	108
Goodyear Gardens Company Town	126
Notes	133
Bibliography	135
Index	137
About the Author	141

ACKNOWLEDGEMENTS

No researcher can make it on her own without the kind assistance of librarians and archivists. I would like to thank Giao Baker, Dace Taube and Michaela Ullmann of the USC Libraries for their cheerful assistance and Yuriy Scherbina, also of the USC Libraries, for his readiness to discuss the content of old photographs of the Los Angeles area. Special thanks go to my family for all of their encouragement and patience.

Approximately half the photographs used in this book come from three historic collections made available courtesy of the University of Southern California on behalf of the USC Libraries Special Collections. The Dick Whittington collection was created by a commercial photographer whose studio was one of the eminent photography establishments in Southern California from the mid-1920s through the 1970s. The *Los Angeles Examiner* photograph "morgue" is a collection of images that illustrate articles in the newspaper from the 1930s through the 1950s. C.C. Pierce, a commercial photographer who documented the growth of Southern California from the late nineteenth century through the 1930s, created the California Historical Society (CHS/TICOR) photographic collection.

Images of the Channel Heights housing project come from slides taken by Fritz Block, a German architect and photographer who lived in Southern California from 1938 until his death in 1955. The Block slide collection is located in the Helen Topping Architecture and Fine Arts Library at USC. Contemporary photographs come from my own personal collection.

INTRODUCTION

Starting at the turn of the twentieth century, the city of Los Angeles quickly grew as an urban center, particularly so in the 1930s and exponentially after World War II. Carey McWilliams, one of Southern California's most astute reporters, wrote in 1946 that Los Angeles's sprawling and centrifugal form was a product of several forces. One such force consisted of large waves of populations from the American Midwest that came to Southern California in the late nineteenth and early twentieth centuries and settled into towns and settlements springing up faster than anyone could account for them. Other factors observed by McWilliams were the proliferation of automobile transportation and real estate cycles that favored horizontal urban development, or what he called a "village pattern in a metropolitan environment."[1]

In this built landscape, planned low- and mid-rise apartment houses competed for real estate with single-family home tracts, garden city–style multi-family developments displaced the rectilinear urban grid of commercial boulevards and Modernist architectural design competed with, and was often assimilated into, historic revival styles. The mixture of contemporary and historic architectural styles was a distinctive feature of the city's urban fabric, noted by locals and by many visitors. In his 1939 satirical novel about the meaning of life, published in the United States as *After Many a Summer Dies the Swan* and set in Los Angeles, Aldous Huxley wrote a succinct passage that described the architectural experience of an Englishman newly arrived in Los Angeles. In this passage, the protagonist, driven through

the city, observes the façades of houses in a well-heeled neighborhood as "elegant and witty pastiches of Lutyens manor houses, of Little Trianons, of Monticellos; lighthearted parodies of Le Corbusier's solemn machines-for-living-in; fantastic adaptations of Mexican haciendas and New England farms." Driving farther, he notes, "[T]he houses succeeded one another, like the pavilions at some endless international exhibition. Gloucestershire followed Andalusia and gave place in turn to Touraine and Oaxaca, Dusseldorf and Massachusetts."[2]

This book looks at the wide dissemination of architectural visual language through a variety of experiences accessible to members of the public, focusing in particular on architectural exhibitions and demonstration homes. Housing and architectural exhibitions were a common occurrence in Los Angeles throughout much of the twentieth century. Some of them were on location with actual homes built in their entirety in specific, widely publicized places. Sometimes they were open to the public for free, as were the Los Angeles Times Prize homes; in other cases, there was a small admission fee. Admission fees were generally charged to defray some of the costs associated with building and displaying demonstration homes. Occasionally, they also went to charitable purposes. For example, the proceeds from the display of the Home of Imagination, designed by architect Richard Dorman and exhibited in Leimert Park in 1953, went to benefit a foundation that aided underprivileged asthmatic children. The Home of Imagination showcased the use of various contemporary building materials, such as stone, wood and glass, and demonstrated the application of technology through such means as a power-controlled sliding door that served as the main entryway. In line with architectural thinking of the day, its design promoted the permeability of exterior and interior spaces while also emphasizing privacy, all thanks to the spatial organization of the exterior.

Exhibition homes built in situ were often raffled or sold after the conclusion of the exhibition, and sometimes they were moved to other locations, as was the case with the homes at the California House and Garden Exhibition, which took place on a plot adjacent to Wilshire Boulevard in Miracle Mile in the mid-1930s. In addition to advocating the ideals of homeownership, housing and architectural exhibitions also served an educational purpose, such as promoting principles of good, practical and artistic design to the public at large. They also purported to introduce innovative features in architecture and interior décor, in construction methods and materials and in the design of appliances. Housing exhibitions and demonstration homes were often located in newly built subdivisions to attract clientele interested

INTRODUCTION 11

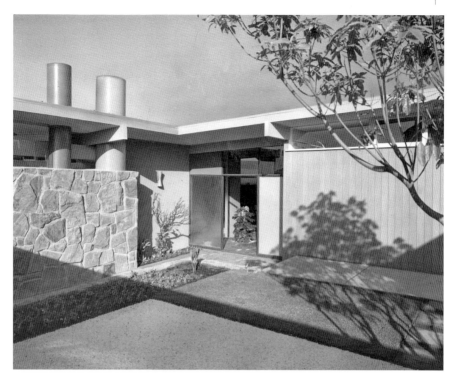

The Home of Imagination was a demonstration house designed in 1953 by Richard Dorman and built by S.J. Tamkin. Proceeds from its exhibition went to benefit underprivileged asthmatic children. *Los Angeles Examiner*.

in the economic potentials of owning real estate, as well as members of the public who took away ideas about the best ways to decorate a home.

In addition to architectural exhibitions on location, there were many others that were held in auditoria, often on an annual basis. These were typically large venues that allowed designers, architects and furniture stores to show the newest of their wares and to introduce new architectural and interior design ideas through temporary construction and displays, in a manner similar to museum exhibitions. Such shows were open to the public, usually for a fee, and ran for several weeks. They, too, served an educational function. Local Hollywood talent, particularly female, was often recruited to both attract audiences and regale them with explanations of particular display and design ideas. When open floor plans came into vogue after World War II, architectural exhibitions showcased how to visually separate spaces used for different daily household activities. For example, a display at a 1954 show replaced the formal dining room with an alcove that could be

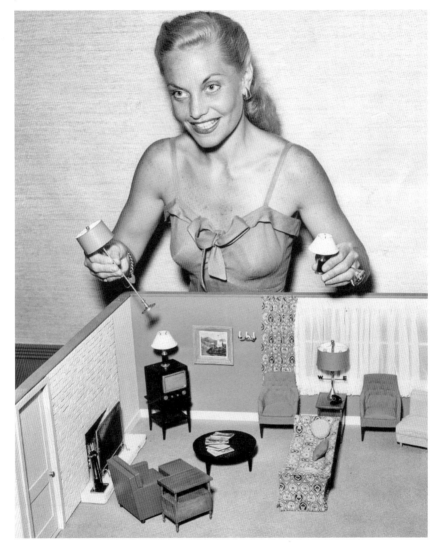

This photograph from the 1952 Home Show in Hollywood Park shows actress Jean Bartel "displaying the ABCs of home decoration." *Los Angeles Examiner.*

used for family meals. It was created by raising the floor level and was further spatially demarcated from the living room through the placement of plants. Decorative wall tiles added a feeling of orderly elegance. The dining alcove was located within easy access to the kitchen, thus also serving as a buffer between food preparation and the leisurely activities that took place in the living room next to it.

INTRODUCTION 13

A photograph taken at an architectural exhibition in 1954 shows how functional spaces can be delineated in an open floor plan through gradation of floor levels, use of planters and decorative tile. *Los Angeles Examiner*.

In this book, I use the term "Modernism" as a catchall phrase to refer to the incorporation of various strains of twentieth-century architectural design into the existing fabric of Los Angeles architecture. Modernist design, both in home architecture and in domestic furnishings, was slow to be absorbed into the local built environment. It was first successfully popularized

14 | INTRODUCTION

Modern furniture designed by Paul McCobb, seen in this 1954 photograph, was widely sold by May Company, as well as other locally owned department stores. *Los Angeles Examiner*.

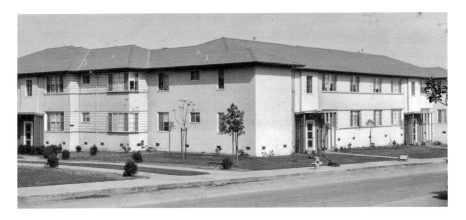

Crenshaw Village, a privately funded garden apartment development completed in 1948, displays many of the hallmarks of Modernist architecture as it was widely adopted in Southern California. *Los Angeles Examiner*.

by interior designers, some of whom were trained in Europe. With its streamlined elegant simplicity and often-practical modularity, Modernist interior décor became a symbol of the future, as well as an embodiment of an aspirational leisurely lifestyle that was open and permeable rather than confined and overstuffed. Modernism's most successful early manifestation in Los Angeles was embodied in the Streamline Moderne architecture. Although the International style did not play a major role in domestic architecture in the city and in Southern California, its specific tenets—such as plain façades, ribbons of windows, rectangular stacked spaces and occasional use of slim support columns and flat roofs—became more common after World War II.

The built landscape of Los Angeles and the surrounding region has been historically analyzed as suburban. Nevertheless, questions of densification and of mid- and high-rise architecture have played an important, still little examined role in the development of the city and are germane to the understanding of its contemporary growth. This book also takes a look at multi-family architecture, both apartments as well as public and private housing developments. Some were designed by architects, such as Richard J. Neutra, whose names resonate nationally and internationally and others by less-known local architects, such as Max Maltzman, who left an indelible and ubiquitous imprint on the built landscape of Los Angeles.

This book concentrates on architecture, but architecture does not exist in an aesthetic vacuum. The development of a city's urban visual language is very much a part of social, economic and political structures that shift over time. Natural conditions, such as Southern California's susceptibility to floods and earthquakes, played a role. Events of national and international importance, specifically the Great Depression and World War II, also left a considerable legacy on the built landscape. Governmental institutions played an important role in shaping the architectural history of Los Angeles and Southern California. So have, famously, real estate investors. Real estate investment, both public and private, had gendered and ethnic dimensions, acutely evident in a rapidly growing region. Sifting through notices of real estate transactions, it became quickly apparent that women held financial powers through various means. The multi-year California Home and Garden Exhibition, described in the first chapter, was the brainchild of two sisters. Publicity on home exhibitions and new construction technologies, and the promotion of new housing tracts, often used both coded and overt language to appeal to women, to encourage investment from certain groups but not from others or to ward off members of certain races and socioeconomic

classes from contemplating renting or purchasing property. A few of these dimensions come through in this book, and scholarship about the history of the region ought to continue mining historic evidence for a nuanced reading of these and other issues.

Part I
ARCHITECTURAL AND HOUSING EXHIBITIONS

Exhibitions of architectural plans, construction materials, household technologies and actual buildings became fairly common and accessible to the public in Los Angeles in the 1920s and 1930s and continued after World War II into the 1950s. World and regional expositions, such as the 1893 World's Columbia Exposition in Chicago, the 1915 Panama-Pacific International Exposition in San Francisco and the Panama-California Exposition in San Diego in the same year, all of which showcased buildings in various architectural styles, set within carefully designed landscapes, provided an important context for the development of large architecture and design-related exhibitions in Los Angeles.

World and regional expositions promoted national pride by displaying agricultural and manufacturing products, but they also played a role in disseminating ideas about cultures and visual styles and helped shape taste through the displays of objects. For example, the exhibition of Japanese architecture at the World's Columbia Exposition was influential in the work of California-based architects Charles Sumner Greene and Henry Mather Greene, who incorporated a Japanese architectural and visual aesthetic into their Arts and Crafts–inspired homes in Pasadena and elsewhere. The Panama-California Exposition in San Diego, which celebrated the completion of the Panama Canal, established the Spanish Baroque Revival style, or Churrigueresque, as a grand style for public buildings and churches in Southern California and introduced landscaping based on Spanish and Mediterranean gardens into wider use.

In covering world expositions, local newspapers were an important source of disseminating information and ideas, describing in detail the architectural, landscaping and technological innovations exhibited. Amalgams of regional revival styles—such as Mission, Spanish, American Colonial and English, which were propagated by the expositions or brought to Southern California by the many immigrants and tourists who settled here permanently—were of enormous importance in shaping the built landscape of the region in the early part of the twentieth century. These popular historic revival styles, although widely disseminated by local architects and builders, were modified by incorporation of regional and, particularly after World War II, new building technologies. Beginning in the late 1930s, Modernist architectural language that favored flat rooflines, plain façades and strategic placement of windows became another important player in the development of local styles.

It is not immediately apparent how directly 1920s European architectural Modernism and interior design contributed to the shaping of vernacular architectural taste in Los Angeles. Arthur Millier, the art critic for the *Los Angeles Times* during this time period, occasionally wrote about the development of Modernist aesthetics in Europe for the newspaper. There does not appear to have been much local reporting on such seminal exhibitions of International-style housing as the Weissenhof Estate in Stuttgart, which promoted very specific and controversial architectural and interior design ideas in single-family and multi-family homes that were designed by various architects in 1927 for immediate human habitation. Nevertheless, architectural Modernism came directly to Los Angeles beginning in the mid-1920s, when some of the European-trained architects settled in the city.

Contemporary plain and streamlined styles also made their way into furniture and household goods sold in some of the city's large department stores. In 1926, the national furniture firm Barker Brothers opened a new shop on the third floor of its building on Seventh Street between Figueroa and Flower Streets in downtown Los Angeles. This store within a store, known as Modes and Manners, was conceived by Kem Weber, a German-born designer, and specialized in Modernist design. "Here, everything is a step ahead of Fashion," proclaimed the first advertisement placed in the *Los Angeles Times* on August 15, 1926. Not all furniture and décor sold at Modes and Manners was necessarily outrageously new in style, but it was also not the overstuffed and over-decorated furniture that symbolized the myth of gentrified European rusticity, which was popularly sold by Barker Brothers at that time. Modes and

ARCHITECTURAL AND HOUSING EXHIBITIONS

Manners specialized in the more streamlined and modern furniture and décor designed by Weber specifically for the company and was marketed to well-to-do customers with sophisticated tastes.

In an article that appeared in the *Los Angeles Times* on March 25, 1928, Arthur Millier argued that American design, as taught in architecture schools and exhibited in museums, lost its leading edge by favoring eclectic historic revival styles that propagated outmoded aesthetic notions. Millier suggested that Americans should look to Europe for more innovative examples on the use of new materials and for fresh ideas on contemporary architecture and interior design that melded structure and function in a more logical manner than historic eclecticism. Millier introduced the concept of machine-age aesthetics to the readers and described it approvingly as exemplifying "a distaste for complicated surface ornamentation; a preference for the straight line opposed by simple curvelinear [sic] elements, and the tendency to treat objects sculpturally" so that a table was "no longer an excuse for the carving of griffin's legs, but a useful article conceived as having a beauty inherent in itself when it best fulfills its function." Significantly, he argued that in the United States it was the department stores, such as Lord & Taylor, Macy's, Saks and Wanamaker, that were disseminating modern ideas about interior décor and singled out Kem Weber's Modes and Manners shop as a local example where modern furniture that expressed American characteristics, albeit in luxurious production, was being sold.

Modernist architectural ideals—such as the melding of form and function through the strategic placement of sources of natural light, the re-conception of the flow of interior and exterior spaces and the elimination of unnecessary ornamentation—became influential, increasingly so after World War II. This was, in part, because industrial products developed for application in the war effort came into use in the construction industry and enabled the realization of some of the concepts. Examples of the application of Modernist ideas to Southern California domestic architecture, as evident in the work of Richard Neutra, Rudolph Schindler, Gregory Ain, A. Quincy Jones, the architects of the Case Study houses and others, became famous worldwide and have been written about extensively. However, these new design ideas, as described by Arthur Millier and others, also percolated into the more ordinary working-class and middlebrow residential architecture. This did not happen immediately, and not wholesale, but became part of the pre– and post–world war building boom, as well as part of an overall effort that began in the 1920s to educate members of the public in becoming more discerning and avid homeowners.

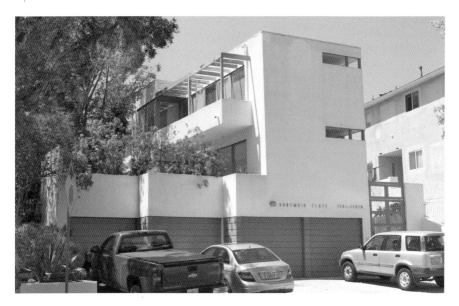

Dunsmuir Flats, a multi-family apartment building designed by Gregory Ain in 1937 and photographed in 2014, is an example of the International style, somewhat unusual in the built environment of Southern California. *Ruth Wallach*.

World expositions, international architectural exhibitions and fashionable department stores were sites that enabled cross-cultural pollination of design ideas, dissemination of technology and, at least in the case of the expositions, displays of national pride. During the Cold War, for example, American architectural expositions in Europe contributed to a reverse flow of cultural exchange by publicizing American wealth and products for consumption abroad. Yet local architectural exhibitions played an important role in the public's acceptance of architectural design styles, interior decoration, use of new building materials and the propagation of invented lifestyles, such as the California lifestyle, with its symbols of leisure and notable incorporation of landscape—often exotic—into indoor-outdoor living.

In the early part of the twentieth century, exhibitions of homes and household technologies were prompted in large part by a concerted national campaign on the part of the federal government and private developers to encourage single-family homeownership. On a pragmatic level, the purpose of the campaign was to educate the general public on the responsibilities of financing, owning and maintaining a home. On a symbolic level, a homeowning population was seen as crucial in protecting the ethos of the American family, which in turn was seen

as the foundation of American society. The 1920 U.S. census revealed that less than half of the American public owned a home. This was in part due to the difficulty of obtaining a mortgage and in part because of the economic stratification of American society in a post–Gilded Age environment that saw enormous fortunes concentrated in industrial hands while the country experienced internal migrations and absorbed large waves of largely poor immigrants. The social and political movements that were sweeping Europe and the United States were also of concern. These movements were perceived as detrimental to the structure of the family as the basic unit of political and social cohesion, thus potentially undermining the foundational and economic values of the country.

In 1922, two years after the troublesome findings of the census, a group of educators and housing experts formulated a national housing campaign called Better Homes in America, which was endorsed by President Harding and by the association of state governors. The purpose of this campaign "was to cure home neglect through an educational program that combined the 19th-century republican values of thrift and self-reliance with 20th-century household technology."[3] In its first year, the Better Homes in America campaign sponsored a variety of activities and publications. Among them was a home exhibition on the White House lawn in Washington, D.C., that, for historic reasons, promoted the Colonial Revival architectural style as an example of specifically American domestic architecture.

The Better Homes in America campaign's mission was to engage all potential homeowners, whether in rural areas or in the cities. Despite its broad purview, it was implicitly geared toward women, who had entered the workforce in unprecedented numbers by the end of World War I yet whose prescriptive and symbolic role remained as that of homemakers. Altogether, campaign promoters believed that the "modern 20th-century housewife should be a trained expert, discriminating consumer, and moral arbitrator within a defined architectural setting."[4] In its first two years, Better Homes in America sponsored home demonstrations in over five hundred communities. The campaign encouraged economic thriftiness to facilitate homeownership and was instrumental in spreading information about the available methods of financing the purchase or building of a home. As Greg Hise explained in his 1992 dissertation, "The Roots of Postwar Urban Region":

> *The benefits of home ownership were disseminated at the local level through demonstration houses, lectures, competitions, and publications dedicated to informing the "general public on the practical details of house architecture,*

construction, and equipment, and each of the processes involved in the purchase or financing of the house and the management of the home."[5]

It is no surprise, then, given that women were an important target of the Better Homes in America campaign, that the principals involved in instructing Americans on how to be better and more knowledgeable homeowners also included many women. On the national level, Marie Mattingly Meloney was influential in spearheading the Better Homes in America movement through her magazine, *The Delineator*. Originally devoted to millinery and dressmaking, with a readership of over one million women, the magazine also disseminated ideas on interior and architectural design to a largely middle-class female audience, deemed to be mostly housewives. The Better Homes in America campaign did not come about suddenly or entirely on its own. Programmatically, it dovetailed into an existing movement for disseminating information about domestic architecture, that of House Beautiful. Descending from English Arts and Crafts design philosophy that influenced notable American and California architects such as Frank Lloyd Wright and the Greene brothers, House Beautiful ideas for homes and garden landscapes were promoted by the eponymous magazine, established in 1896, which sponsored home design and gardening competitions and exhibitions throughout the twentieth century. From the late 1920s to the mid-1930s, several House Beautiful exhibitions were brought to Los Angeles as a way of fostering exchange of ideas among architects and builders while also attracting a primarily affluent audience of women, who took the ideas to their social clubs and their homes.

Architects' Building Material Exhibit

An important, although not unique, locus of architectural exhibitions in Los Angeles was the Architects' Building Material Exhibit. Initially organized in 1914 on the sixth floor of the Metropolitan block, which was located at the corner of Fifth Street and Broadway, by Marie Louise Schmidt, its purpose was to establish a permanent space to exhibit materials used in buildings and furnishings so that builders and architects could easily show them to their clients. The space was also intended to host rotating exhibitions on topics related to art and architecture, which would be open to the general public and to high school student groups.

ARCHITECTURAL AND HOUSING EXHIBITIONS ✳ 23

Marie Louise Schmidt—who, somewhat unusually for the time, was known by her maiden name—and her sister, Florence, were both tireless advocates of architecture and the building trades in Los Angeles. Marie Louise managed the Architects' Building Material Exhibit for many years. In 1927, she secured funding for a new twelve-story building on the southeast corner of Fifth Street and Figueroa and in 1957 moved the exhibit to Third Street, west of Fairfax Avenue, where it remained into the 1970s and was known as the Building Center. According to a *Los Angeles Times* article from September 29, 1957, the Schmidt sisters' mission was to foster a closer relationship "between the professions and the manufacturers and suppliers of materials and equipment used in building, decoration, and site development." Over its many years in downtown Los Angeles, the Architects' Building Material Exhibit sponsored a variety of architectural design events that both educated the public and directly involved it in design. For example, in 1930, the exhibit sponsored the Kitchen Competition, which had two separate awards for the best (or a more perfect) kitchen, one for a design by an architect and one for a design by a "housewife." It also held competitions for best design of specific housing types, such as "small-type residences" or "beach cabins"; exhibitions on structural technologies and building materials; and exhibitions on the architecture of vernacular styles that the sisters thought appropriate for Southern California living.

In 1928, the Architects' Building Material Exhibit organized a House Beautiful Exhibition of Homes. This exhibition was sponsored by the House Beautiful Publishing Company as part of its nationwide architectural competition for beautiful and well-appointed homes. It included plans and descriptions of fifty homes. Its mission was to introduce Angelenos to architectural designs that won various national prizes, as well as to educate the local public, which in the words of collaborating architect H. Roy Kelley displayed an astounding lack of good taste and knowledge of style in decorating homes. However, Kelley's strongest criticism on the deplorable state of local architectural taste was reserved for real estate and urban planners. In his exhibition review published in the *Los Angeles Times* on July 1, 1928, Kelley wrote:

> *The results of the real estate promoters' dreams are appalling; straight streets, bare of foliage, each house located with a total disregard for the others and the general surroundings; contractors and mail-order designs of every hideous and evil form, and "jazz types" of every description and color.*

Despite this scathing criticism of local design and building practices, the House Beautiful exhibition promoted common vernacular revival styles—such as English, Colonial and Spanish—which, critics explained, were all pleasingly adaptable to the environment and landscape of Southern California. Kelley had more than a critic's interest in the shaping of the public's architectural tastes—a home he designed in the English Revival style for Dr. Walter C.S. Koebig in Pasadena won one of the prizes in the national House Beautiful competition for small homes that year. After bringing the national exhibition to Los Angeles, the Architects' Building Material Exhibit collaborated with Barker Brothers, the national furniture dealer with a major presence in Los Angeles, to sponsor exhibitions of sketches and photographs showing "new" home designs in order to "Americanize" the built landscape of Southern California. For example, the Colonial Revival style, also referred to as Georgian Revival, common on the East Coast, was presented as an ideal American home style appropriate for any locale, including Los Angeles. In 1929, H. Roy Kelley wrote that Southern California's Spanish Revival architecture had become too faddish and thus foreign to the Anglo-Saxon architectural style he favored in his practice. Recognizing the importance of the historic roots of the Spanish Revival style, he sought to preserve its romanticism by melding it with Colonial Revival, thus advocating for a picturesque, livable and adaptable hybrid style.

California House and Garden Exhibition

In the 1920s and 1930s, architectural exhibitions helped shape the idea—which was shared by architects and builders—that Los Angeles was a place to adopt and adapt a variety of architectural styles and building practices so that its built landscape could move beyond the region's Spanish and Mexican colonial heritage. One such architectural exhibition was an outdoor show, which started in 1936 and ran for several years in the fairly new development on Wilshire Boulevard known as Miracle Mile. Called the California House and Garden Exhibition, it was organized through the Architects' Building Material Exhibit by Marie Louise Schmidt and her sister, Florence Schmidt. The exhibition was located at 5900 Wilshire Boulevard, between Spaulding Avenue and Genesee Street, opposite what became, in 1965, the campus of the Los Angeles County Museum of Art. It was part of the Better Homes in

America campaign and was sponsored by the chamber of commerce, the Federal Housing Administration and various local civic and garden clubs. Similar to other exhibitions nationwide during this time period, its intent was to demonstrate the architectural design of affordable homes, showcase house-related products and building technologies and educate the general public in the fine art of home financing. The initial exhibition featured six demonstration homes, each designed by a local architect in different styles. All construction costs had to come under $5,000 per house, a figure seen as just about affordable for a middle-class family. Almost two hundred manufacturers, interior decorators and landscape architects contributed materials and labor.

The California House and Garden Exhibition was first announced in the *Los Angeles Times* on September 15, 1935, when a five-year lease for the block was signed by Marie Louise Schmidt. Its purpose, as stated by the *Times*, was to "visualize and emphasize the importance of modern home construction methods." Schmidt, who, together with her sister, penned the weekly "Construction Primer" advice column in the real estate section of the *Times*, hoped to open the exhibition in November of that year. This turned out to be too ambitious, and after some delays, the exhibition formally opened on April 17, 1936. The first advertisement, which ran in the *Los Angeles Times* on April 12, 1936, described the six demonstration homes as "representing the finest types of English, French, Modern, Farm, Californian and New Orleans architecture—completely and appropriately furnished and equipped with every modern convenience." The exhibition had "[b]eautifully landscaped grounds…Rose Gardens…

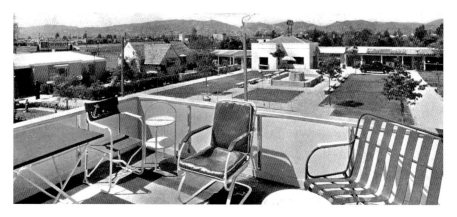

A view of the California House and Garden Exhibition from the porch of Richard Neutra's Plywood house. *From* Architectural Digest *9, no. 3.*

Lily Pond…Rare Birds…Orchid Exhibit…Even a Badminton Court has been included to make this a perfect picture." General admission to the exhibition was twenty-five cents.

The exhibition was designed as a hamlet and had its own temporary streets. In the center of the hamlet was a landscaped plaza-like area, designed by Charles G. Adams, with public seating and a fountain. Demonstration homes, exhibition spaces, a radio station and administrative facilities were built around it. The houses constructed for the original display were as follows: a California cottage by the architect Winchton Leamon Risley and interior decorator Harry Gladstone; a New Orleans–style house by the architects John Byers and Edla Muir in association with interior decorators Cannell & Chaffin; a Moderne house, also known as Plywood house, by Richard J. Neutra; an English cottage by Arthur Kelly and Joe Estep, with interior décor provided by Anita Toor; a French-style house by Paul Revere Williams, with interior design supplied by Cannell & Chaffin; and an Economy cottage designed by Gordon B. Kaufmann and Allen G. Siple. Gardens and landscaping for the houses were designed by Hammond Sadler, Charles G. Adams, Ralph D. Cornell, Seymour Thomas, Edward Huntsman Trout and George Kern. The architects used various newly available building technologies. For example, Paul R. Williams used a steel frame with plaster exterior for his French-style house. Kelly and Estep's English cottage was built of reinforced grout lock brick masonry, and Risley's California house was constructed of hollow concrete building tile.

Richard Neutra's house was, predictably, the most modern in style. In contrast to the other five houses, which were of masonry, brick and steel, this house was described by the Schmidt sisters in their column on July 26, 1936, as having "exterior walls of timber chassis covered with insulating material and faced with weatherproof super-plywood outside and five-eighths-inch mahogany plywood on the inside. The interior partitions are of plywood on wooden studs." True to his trademark emphasis on outdoor living, Neutra designed a sun deck and a sleeping porch on the second story. The entry was on the side, partially hidden by an overhang and a supporting column, as well as by some landscaping features. An article about the exhibition that appeared in the *Architectural Forum* in July 1936 noted that the Plywood home's plan was notable for "the relatively large area allotted to the living room, and the luxurious quality of the interiors due to this spaciousness." It also noted the soft lighting in the overhangs as an innovation in interior design. The structure and materials of the Plywood house represented concepts on which Neutra was working for some time; a somewhat smaller version of this

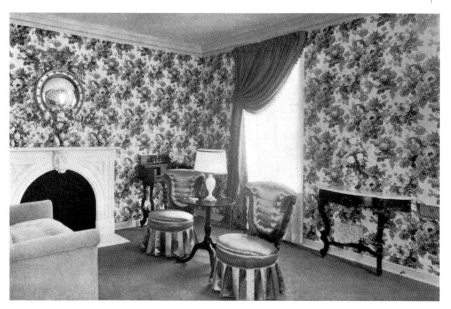

The interior of the New Orleans house exhibited at the California House and Garden Exhibition. The demonstration house was designed by John Byers and Edla Muir. *From* Architectural Digest 9, no 3.

design had won second prize in the national General Electric Small House Competition held the previous year. The other exhibition homes were more conventionally styled, with pitched roofs, clearly delineated façades and visible frontal entrances.

A practice at the California House and Garden Exhibition was to leave a portion of each house uncovered to show hidden materials. Where this was not possible, materials were displayed in an exhibition arcade adjoining the administration building. Architect Gordon B. Kaufmann, in addition to contributing a house, also designed the exhibition administration building and the concrete wall separating the hamlet from Wilshire Boulevard. Reflecting H. Roy Kelley's criticism that Spanish Colonial Revival architecture was no longer an adequate idiom for the shaping of the public's taste in housing, none of the exhibition homes reflected this style, not even the California cottage. Although the organizers of the exhibition promoted the idea of novelty in construction, the architectural and decorative styles, with the exception of the Plywood house, were vernacular, reflecting a historicized visual language as more appealing to the prevailing public tastes.

The locally published journal *Architectural Digest* and the nationally known journal *Architectural Forum* ran articles about the exhibition in the summer

of 1936 that outlined in great detail information about materials used and the manufacturers who supplied them. *Architectural Forum*, a professional publication for architects, included a critical analysis of some of the individual homes on display. It lauded Neutra's Plywood house. The article lauded the plan of Winchton Risley's California cottage as compact and well organized for use, with simple and well-appointed interiors and a good relationship between interior and outdoor living spaces. It also noted approvingly that, for its size, the cottage had a spacious living room. The magazine's evaluation of Arthur Kelly and Joe Estep's English cottage was more critical. According to the article, this architectural style was never entirely popular in California, but it acknowledged the appeal of its traditional interior to some visitors. The article critiqued Paul Williams's design of French cottage within the framework of the effect of "the California climate on imported styles." According to *Architectural Forum*, the home's French architectural language was exemplified in its "vaguely reminiscent roof and the potted trees by the door. The plan, with its circular stair, elliptical dining room, and splayed kitchen is perhaps more characteristic of chateau than of cottage architecture." The original exhibition display included a Better Homes cottage, also known as the Steel House, designed by Paul Williams. Steel House, an example of an affordable home, was typical of Williams's work, combining new materials with a familiar visual language, melding the more traditional vernacular architecture with clean, modern lines. Its exterior and interior were simple, with structural unity provided through the use of metal siding and metal roofing.

Alma Whitaker, a correspondent for the *Los Angeles Times*, confirmed in her column who the primary target audience of the Better Homes program was, writing, "Of course, they've let a few men in on it, you understand, but that entrancing House and Garden Exhibition at 5900 Wilshire Boulevard is essentially a women's project."[6] Whitaker praised the Schmidt sisters for seeing the exhibition through at a time when "many were scared of new ventures," possibly implying that men, who occupied most of the building and financing trades, were still leery of grand ventures after the Great Depression. Whitaker also praised the sisters for getting the support of the Los Angeles Chamber of Commerce, the Federal Housing Administration, building contractors, furniture dealers, landscape designers and others connected with the building industry. She went on to describe the exhibition homes in terms of their gender appeal. Winchton Risley's California cottage was replete with domestic romance and equipped with "every modern gadget dear to the heart of woman." Architect Edla Muir was occasionally on hand

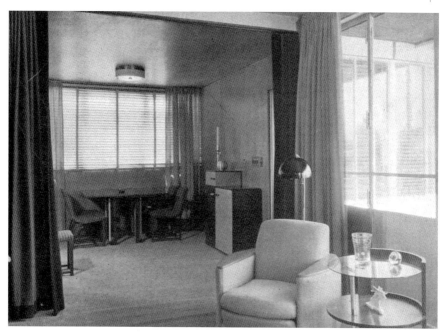

The straight lines, sparse décor and large windows of Neutra's Plywood house supposedly had a strong masculine appeal. *From* Architectural Digest 9, no. 3.

to host revelers in her and John Byers's New Orleans house, appealing to the wives, who, according to Whitaker, could "snare the husband along to view the joyously varied possibilities" inherent in the vernacular style of this and other exhibition houses. Whitaker rated Neutra's Plywood house as "highly modernistic and essentially masculine. Men, without exception, vote for this one. Straight lines, huge windows, chairs for masculine comfort and the kitchen…designed to gladden the heart of a male cook!"

Paul Williams's French-style house had an eminently feminine appeal, whereas both the Economy cottage by Gordon Kaufmann and Allen Siple and the English-style house by Arthur Kelly and Joe Estep were said to appeal to both sexes. Once everyone was satisfied with viewing the model homes, representatives of the Federal Housing Administration were on hand to explain financing possibilities to potential homeowners.

A brochure was compiled for the occasion of the exhibition. It provided information on some of the demonstration homes and on a selection of other examples of affordable houses built in Southern California and included architects' names and addresses. The brochure also featured short articles about a variety of subjects, such as decorative sculpture, which

was seen as an antidote to the rigid angles and hard planarity espoused by Modernism, and about the appropriateness of including murals in interior décor, particularly for children's rooms. Also included was a detailed article on the types of loans that had recently become available to assist with homeownership. It provided information on budgeting for the purchase of a new home, financing the building of a home, getting a mortgage plan insured through the Federal Housing Administration and refinancing an existing mortgage. The article, penned by Fred W. Marlow, who was district director of the Southern California district of the Federal Housing Administration and one of Southern California's most prominent housing tract developers, advised prospective buyers to allocate one-fifth to one-third of a family's income for housing.

At the conclusion of the first stage of the exhibition in October 1936, Winchton Risley's California cottage, with its enclosed patio, was voted favorite by the visitors, followed by the English cottage, the New Orleans house, the Moderne (Plywood) house, the French house and the Economy cottage, in that order. Tens of thousands of people visited the display of homes during the course of the first six months, with nominal admission fees going toward reimbursing the builders. Marie Louise Schmidt's ambition was to make the exhibition permanent, or at least long term. To this end, the organizers held a periodic contest among the visitors, the winner getting one of the houses, which was then moved away and replaced by a new one, designed in a different style. There is no record of the mechanics of this process, where the homes were moved or of their subsequent fate. The participating builders and manufacturers also came up with their own plans to keep public interest heightened, holding monthly breakfasts for the exhibitors, occasional fashion shows, a badminton tournament, garden parties and several radio broadcasts. For a while in its early days, the exhibition also featured an aviary with tropical birds from exotic countries.

Other home designs were displayed in quick succession at this location through 1936 and 1937, either in built form or in exhibitions of architects' sketches. The majority of the demonstration homes were designed in vernacular architectural styles, relatively modest in size, and promoted as suitable for small families. Many addressed specific environmental issues. For example, the exhibition featured a California home suitable for year-round desert living, designed by Lyle Nelson Barcume and described as exuding a close-to-earth feeling. Another exhibited house with a garden was designed by C. Hugh Gibbs for a long and narrow urban lot. The houses and plans displayed at the California House and Garden Exhibition over

its approximately two-year run ranged from about one thousand to three thousand square feet in size and cost between $4,000 and $10,000 to build. They were periodically featured and described in great detail in the Schmidt sisters' "Construction Primer" column in the *Times*.

A notable exception to the pricing range was the "Colonel Evans Package House," a dwelling that could be sold completely over the counter, in a manner similar to the early Sears prefabricated kit houses. It was named after Colonel William H. Evans, an administrator at the Federal Housing Administration who supervised the agency's Better Homes campaigns. This house, manufactured by the Economy Housing Corporation under the direction of consultant Frank W. Green, a local architect, was heralded specifically as a low-cost model. It was a five-room structure (which most likely meant two or three bedrooms) with a low-pitched roof and cost under $3,000. The garden for its display was designed by landscape architect Patricia Shellhorn. Information accompanying the Colonel Evans Package House, which was exhibited in May 1937, also included statistics pertaining to family income and homeownership in Los Angeles County, compiled by the Marketing and Survey Department of the *Los Angeles Times*. Accordingly, the county had over 257,000 families with annual income under $1,000; 370,000 families with annual income between $1,000 and $3,000; and 103,000 families with annual income ranging between $3,000 and $20,000. The Marketing and Survey Department found that less than 41 percent of the families with annual income between $1,000 and $3,000 owned homes. The Package House was intended for and marketed to those in the lower income brackets who were not yet homeowners.

The California House and Garden Exhibition closed in early 1938, and there is no evidence of what happened to the exhibited structures. In their weekly *Los Angeles Times* column, the Schmidt sisters not only included sketches of the floor plans and detailed information about building materials and interior design but also rationalized the disposition and size of the rooms and of the landscape, implicitly suggesting the relationship between communal (e.g., family) and individual spaces and between indoor and outdoor living.

Organizing and promoting architecture and the building trade was a life-long mission for the Schmidt sisters. Their original idea that the California House and Garden Exhibition be a permanent hamlet displaying new home architecture, home-building technologies, products and interior design was possibly one of the most ambitious projects to promote the philosophy of homeownership and middle-class lifestyle

in the Los Angeles area. The exhibition exemplified the sisters' genuine desire to educate the general public on issues related to architecture by bringing an extensive network of builders, architects and landscape architects together for this purpose. Although long gone, the California House and Garden Exhibition also left its palimpsest-like physical imprint on the place where it was located. While most north–south streets in this location go straight through Wilshire Boulevard, Genessee Avenue turns westward and joins Ogden Drive just south of Wilshire, curving around what once was the site of the exhibition village.

Post War House

In the immediate post–World War II period, Los Angeles experienced a great demand for housing, which began much earlier in the twentieth century and increased rapidly during the war. Real estate developers, such as Fritz B. Burns, who was also president of Henry J. Kaiser Homes, began offering homes and many modern amenities in standard prefabrication in order to not just meet the demand for housing but also shape lifestyle choices of a growing middle class. Burns established the Fritz B. Burns Research Division for Housing in 1943 to engage in scientific research on modern housing and to study consumer interests and needs as related to homeownership. Under the leadership of Joseph Schulte, the division studied the efficiency and viability of new materials for prefabricated home construction. It also produced publications that provided advice for homeowners for care and repair of homes. These publications received sponsorship from Los Angeles–area manufacturers and merchants in exchange for endorsement in the text. Most importantly, the division was a laboratory to try new products, materials, designs and methods of construction. Fritz B. Burns's core belief was that homebuyers wanted to see familiar designs. This was in contrast to the innovative, Modernist and often unusual ideas for home construction and design of living and outdoor spaces that were practiced by the architects participating in the contemporaneous Case Study houses project organized and funded after the Second World War by John Entenza and the journal *Arts & Architecture*. To showcase new housing technologies as enabling the post–World War II middle-class lifestyle in Southern California, the Fritz B. Burns Research Division for Housing funded a noteworthy home exhibited shortly after the end of the war.

ARCHITECTURAL AND HOUSING EXHIBITIONS

The division's research house project was not unique by any means. A notable example of a research house was Richard J. Neutra's VDL, which the architect built and later rebuilt (as VDL II) for himself and his family in Silverlake. The concept of the research house that scientifically examined innovations in construction and household technology carried forward into the 1950s and is occasionally used today, as well. Arguably, however, the Burns Research Division house was the most hyped and the longest lasting as a public exhibition.

Initially called the Post War House, the exhibition home was constructed on the southeast corner of Wilshire Boulevard and Highland Avenue (at 4950 Wilshire) and opened to the public on March 3, 1946. The house was a collaborative project between the division and architects Walter C. Wurdeman and Welton D. Becket. Landscaping for the Post War House was designed by Garrett Eckbo. Its purpose was to demonstrate building materials and technologies that were initially developed during World War II and readapted for civilian use, as well as to envision a contemporary middle-

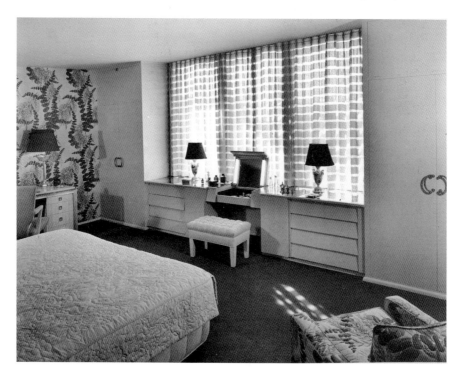

A photograph of a bedroom, designed in a style that was simultaneously recognizably traditional and contemporary, displayed in Fritz Burns's 1946 Post War House demonstration home. *Dick Whittington*.

class residential lifestyle that incorporated indoor and outdoor living spaces. The Post War House cost what for the time period was a whopping $175,000 to construct, with over one hundred manufacturers supplying products for it and Bullock's department store providing furnishings designed in a hybrid style that was inspired by both Modernist clean lines and the more familiar color schemes and fabrics.

Perhaps not surprisingly, given Burns's belief in the importance of recognizable and habitual architectural idioms, the house was architecturally understated, despite the fact that both architects—and particularly Becket—were known for their Modernist design of commercial and cultural buildings. According to Dana Cuff's insightful analysis, the Post War House's purportedly innovative and "futuristic" components were primarily programmatic rather than architectural. The Burns Research Division and the *Los Angeles Times* promoted the house as an educational exhibition and a demonstration home to test the public's taste for and interest in scientifically designed household technologies. The division made it clear that this was not a model for sale. Nonetheless, in its articles and advertisements, the *Los Angeles Times* slyly used the house to stimulate consumer interest, even if some of the features were newly developed, experimental and not immediately available for purchase. As Beatrice Ayres Lamb wrote in her article on March 31, 1946, "Neither the architects nor the builders will duplicate it [i.e., the house] at any price. Much of the unusual material and equipment in it is not now and, indeed, may never be available to you. But you will want to own it."

The arrangement of the interior space in the house was supposedly based, at least in part, on surveys of consumer preferences conducted by the Research Division. Thus, the post–World War II Los Angeles–area public apparently evinced a dislike for formal dining rooms, preferring, instead, to eat informal family meals in the kitchen breakfast nook and to entertain guests in an alcove that opened to the living room. In response to such sentiments, the architects designed a spacious and open kitchen, which featured discreet spaces for equipment and food preparation; a small family-eating area; and a larger space that could seat at least ten people for entertaining within proximity to the food preparation equipment, since the modern family was unlikely to have hired help. Apparently, residents of Southern California came to prize privacy above all else, and thus much of the front of the house on both the Wilshire and Highland sides was designed as a high wall of various materials topped with clerestory windows and a barely sloping overhanging roof that framed a rectangular glass-enclosed entry. For further privacy, the house, which lacked

ARCHITECTURAL AND HOUSING EXHIBITIONS ✹ 35

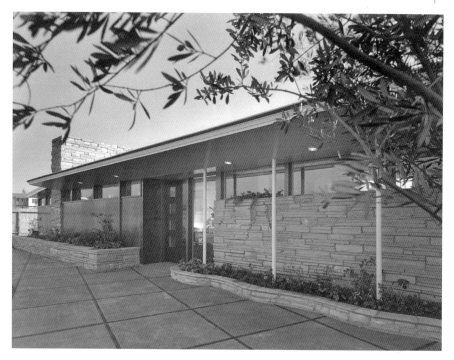

A view of the exterior of the Post War House, which shows use of flagstone as a surface and as a landscaping feature. *Dick Whittington*.

a discernible façade, was set back from the street, particularly since the street in question was the busy Wilshire Boulevard. The exterior throughout was treated with redwood paneling and with Arizona flagstone, the latter also used as a wall for landscaping features.

According to Dana Cuff, this relatively unadorned exterior, purely expressive in its use of wood and stone, showed the influence of architectural Modernism in Wurdeman and Becket's work. During the exhibition, the builders highlighted a variety of functional installations, the purpose of which was to reduce housekeeping labor, such as dusting and cleaning of surfaces, citing the fact that many middle-class households no longer had hired help. The Post War House showcased the first electric garbage disposal, an automatic climate control system, two-way intercoms between all the rooms, the first residential large-screen television and other new domestic technologies. The kitchen had washable walls that could be easily wiped clean. It was reported that division employees exhibited this with a dramatic gesture, smashing a bottle of ink against the smooth white walls and then easily wiping the ink away.

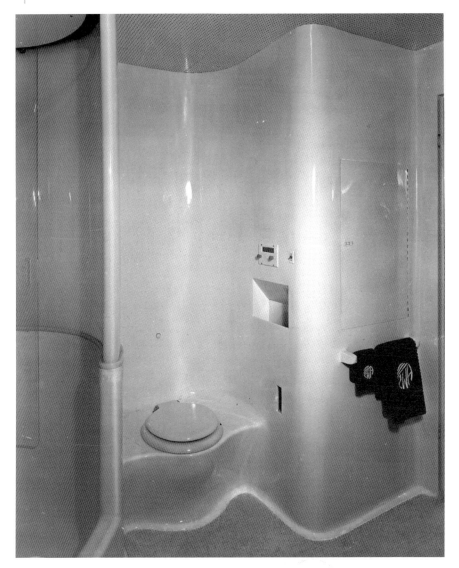

Henry Dreyfuss designed the bathroom in the Post War House as a continuous sheet with molded depressions for fixtures. *Dick Whittington*.

The *Los Angeles Times* devoted an entire article just to the wonders of the kitchen and the laundry, alluding to a vision of a postwar gadget-savvy, multi-tasking housewife whose movements were, by implication, scientifically engineered. The article described in great detail the kitchen's size and disposition of working and eating spaces, its cabinetry,

"food preparation center," the scientific design and distribution of equipment such as food mixer and the sewing machine and exulted in the excitement of the laundry drying facilities. Each room had room-length closets with sliding doors, a feature that soon became common in domestic interiors. The design of the bathroom, by Henry Dreyfuss,

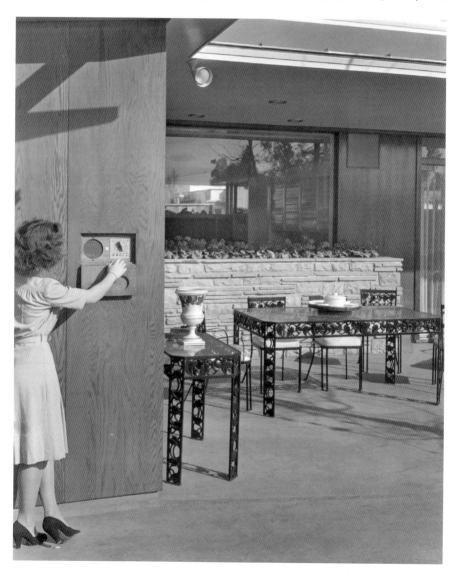

Among the many modern amenities in the Post War House were radio controls that were installed in all the rooms and in the patio, which effectively functioned as an exterior living space. *Dick Whittingon*.

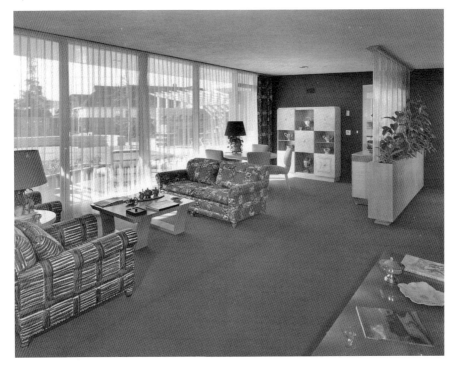

A view of the living room in the Post War House, which shows use of furniture and partitions to delineate functional spaces. *Dick Whittingon.*

was notable for its continuous streamlined sheet of porcelain-finished metal that fit smoothly over surfaces, with molded depressions for the washbasin, tub and toilet bowl.

Radio and record player controls were available in all the rooms and in the patio, allowing for a different program to be heard in each room and on the terrace, the latter furnished and appointed to function as an outdoor living room. The television set, a complete novelty at that time, was installed as part of the living room's fireplace mantel. Burns understood that public tastes favored a vernacular furniture décor over the more modern and cerebral design. In the open plan of the living room, with its strategically placed partitions that subtly delineated spaces, "the decorators chose modern furniture that retained the best lines of previous periods…and softened the whole effect by generous use of living plants, copper, brass, silver, and ceramic objects." The overall color scheme in the house's interior was based on beetroot red coupled with shades of gray, purple, chartreuse, green and, in the kitchen, white.

Initially, entry into the Post War House cost fifty cents, soon raised to one dollar, and over one million people visited it in the next four to five years. The proceeds went to charitable organizations identified by Fritz Burns, particularly to St. Anne's Foundation and the St. Sophia Greek Orthodox Cathedral. Eventually, public attendance declined. At the behest of Burns, the Post War House was renovated into the House of Tomorrow by Welton Becket (Walter Wurdeman died in 1949) and reopened to the public on March 17, 1951. It was not radically different from its predecessor. Retaining the Post War House's original *U* shape, the House of Tomorrow remained turned inward, focusing on the interior patio, in contrast to the more conventional frontal organization of much residential housing in the pre–World War II period. The renovated 2,400-square-foot house continued promoting the idea of an informal California lifestyle, emphasizing even more the permeability of indoor and outdoor spaces than the Post War House.

The theme of indoor-outdoor living was not unique to Burns or Becket and was explored for several decades by many architects working in Southern California. The House of Tomorrow featured custom-made furniture in a contemporary French Provincial–inspired style, which was provided by Barker Brothers. Other notable features included terraces for each of the bedrooms, a patio that had radiant heating for the colder months and a kitchen that featured a central island with a sink, a breakfast bar and storage space for dishes. The living, dining and family rooms had one wall made entirely of sliding glass, opening onto the terrace area, which contained a barbecue kitchen. The house had two bedrooms in all, indicating that the future middle-class family would be small. Yet the House of Tomorrow occupied almost twice the square footage than that allocated in many residential tracts, such as ones built in Westchester by Fritz B. Burns himself in collaboration with Fred W. Marlow; in Lakewood by Mark Taper, Louis Boyar and Ben Weingart; and in many other rapidly growing post–World War II single-family housing communities in the Los Angeles area, where new homes were often between 900 and 1,100 square feet in size. Martha Weaver and W.G. Winsor, designers employed by Barker Brothers, used bluish gray and deep green as the color scheme for the House of Tomorrow's interior décor, purportedly to harmonize the interior with the landscape and the atmospheric colors of the exterior.

Included in the one-dollar admission was entry to the so-called Nutmeg House, located at 702 South Highland Avenue just south of Wilshire Boulevard. This was a small two-bedroom home furnished with Barker

Brothers' new collection of budget-priced "provincial" furnishings. Dubbed as the House of Today, Nutmeg House was built by Kaiser Homes to show that even a modest house, the size of typical post–World War II tract homes, could be colorfully appointed with contemporary furnishings at a reasonable price. After the exhibition ran its course in the late 1950s, Fritz Burns converted the House of Tomorrow into an office for his realty firm. In later years, it served various other organizations, including a private school. The House of Tomorrow and the Nutmeg House still stand in their original locations, although considerably altered.

Annual Home Shows

Although the California Home and Garden Exhibition and the Post War House/House of Tomorrow were notable for their multi-year runs and for the aspirations of their designers to make them permanent, Los Angeles was a site of many temporary home and architectural shows that provided inspiration for developing homeowner tastes and lifestyle expectations. These shows also disseminated practical information about interior décor and owning and caring for new household appliances. The Pan-Pacific Auditorium on Beverly Boulevard near Fairfax Avenue, Hollywood Park in Inglewood, Santa Monica Civic Auditorium and the Los Angeles Memorial Arena (known as Coliseum) just south of downtown Los Angeles were some of the many locations for local and national shows of homes and household technologies beginning in the 1930s and running into the 1950s. Particularly in the 1930s, such exhibitions also provided extensive information on homeownership and on obtaining mortgage loans. To entice members of the public, they were publicized as providing information on the aspirational lifestyles of the future. Futuristic design, however, was not always in evidence, although it became a more prominent feature in the 1950s. Particularly before World War II, exhibitions were more likely to promote heretofore-unavailable technologies, such as automatic garbage disposals or electric-powered laundry appliances. Through the decades, Modernist architectural design and contemporary construction and appliance technologies were displayed together with the more traditionally inspired vernacular décor.

Pan-Pacific Auditorium, designed by Charles Plummer, Walter C. Wurdeman and Welton D. Becket in a Streamline Moderne style, was constructed in 1935 in time to host the National Housing Exposition, which

ARCHITECTURAL AND HOUSING EXHIBITIONS 41

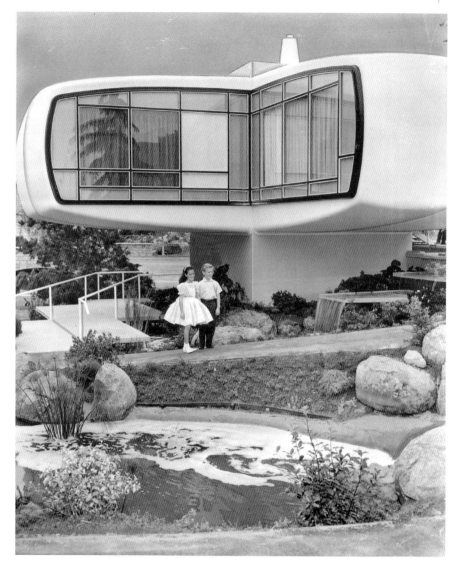

A futuristic design for Monsanto Company's demonstration home called House of the Future, made mostly of plastic and exhibited in Disneyland in 1957. *Los Angeles Examiner*.

opened on May 18 with the motto: "Southern California Marches On." It was called the largest exhibition of its kind, which may have been true for Los Angeles, still emerging from the status of a cow town despite its burgeoning population and suburban growth. Significantly, the exhibition's timing coincided with the country emerging from the Great Depression. The

construction market in Los Angeles, as elsewhere, was being stimulated by loans made available under the provisions of Title II of the Federal Housing Act. At the National Housing Exposition, the *Los Angeles Times* sponsored a model home encased in what the newspaper called a Unitype steel frame (so called because it was supplied by Unitype Builders Inc.) that was resistant to termites and rot and able to withstand earthquakes. This demonstration home was unsurprisingly referred to as the House of Tomorrow (not to be confused with Fritz Burns's eponymously named demonstration home of a decade later).

Designed in a modernized California ranch–style architectural idiom (also referred to during the exhibition as a "suburban cottage") by H. Roy Kelley, Edgar Bissantz and Harold G. Spielman, the House of Tomorrow was 1,700 square feet in size, considerably larger than many contemporary homes that were affordable to middle-class families. Visitors entered through a rectangular trellised porch into an entrance hall flanked on one side by the dining room, kitchen and pantry and on the other side by the living room. The two bedrooms, which were separated from the public quarters by a small hallway, had a terrace on each side. The house was proofed with Insulite, which also provided sound protection for the rooms. It was faced on the exterior with salmon-colored Roman brick, set off by the white-painted trellis, and had steel-framed windows. The interior was furnished by the Los Angeles Furniture Company in keeping with its simple and unadorned architectural style. The House of Tomorrow featured a two-car garage, which could be opened electrically, a novelty at that time. After the exhibition, it was given away by the *Times* and moved to the Valley Park area of the San Fernando Valley, to a landscaped site near the intersection of Ventura and Van Nuys Boulevards specifically laid out for it by Katherine Bashford, and offered for sale.

As for the rest of the 1935 National Housing Exposition, two hundred exhibitors provided materials deemed appropriate for erecting and furnishing the "ultra-modern" American home, an aspirational term used to promote this exhibition. Major furniture stores, such as Barker Brothers, Bullocks and May Company, exhibited furniture "of the future," some of it designed by Kem Weber and Gilbert Rohde, both of whose work was Modernist and Streamline Moderne in nature. Among the homes displayed inside the Pan-Pacific Auditorium was one made of glass and completely furnished, in which a woman named Edna Kirby lived and went about her daily business during the duration of the two-week exhibition, as if in a fishbowl. A mobile honeymoon cottage, designed by

ARCHITECTURAL AND HOUSING EXHIBITIONS 43

The exterior of the House of Tomorrow, designed by the architects Kelley, Bissantz and Spielman and exhibited in 1935 at the Pan-Pacific Auditorium. *From* California Arts and Architecture, *July 1935.*

architect Wallace Neff, appears to have also been given away as a prize at the end of the show. The *Los Angeles Times* heavily promoted the more conventional demonstration homes, particularly low- to medium-cost houses. For the duration of the show, employees of the Federal Housing

The living room of the 1935 House of Tomorrow shows a combination of styles evident in the design of the furniture and in the use of materials for interior décor. *From* California Arts and Architecture, *July 1935*.

Administration were on hand to distribute home financing information to members of the public. This tremendous display of contemporary design was so impressive that over fifteen thousand visitors to the exhibition inquired about housing loans, with the majority seeking information on purchasing new homes rather than refurbishing existing ones.

The Pan-Pacific Auditorium continued hosting home and building expositions in the period after World War II, although with somewhat less hype than was accorded the 1935 exhibition. Immediately after the war, the exhibitions appear to have become somewhat more conventional, although some used industrial materials that were originally developed as part of the World War II economy. Cost-cutting measures were deemed more important than unconventional contemporary design. For example, during the National Home and Building Exposition in 1949, the two homes designed by Allen G. Siple were intended to demonstrate that private enterprise was able to provide consumers with medium- and low-cost housing that was better than the publicly funded housing that became a common staple of the built environment in Los Angeles and elsewhere in the United States. The

two homes, one larger than the other, were designed in a simplified ranch style, with shallow-sloping roof overhangs. The living room of the larger house used plain natural brick with exposed wood beams. Martha Weaver, a designer with Barker Brothers, gave the furnishings a French provincial theme. Unlike Wurdeman and Becket's contemporaneous Post War House, which was designed to merge certain family functions in a relatively open floor plan, Siple's floor plan kept them separate. Specifically, the living room was completely separated from the rest of the house by a breezeway and a patio. "In this house," wrote Virginia Zimmer, "there is no chance for kitchen chores and fuss to invade the living room. Nor can the radio and conversation in late evening penetrate the bedrooms."[7] The smaller of Siple's homes was 450 square feet, more of a cabin than a house, and contained one multipurpose space, a kitchen and a bathroom. To provide a sense of color in a small space, and to complement the redwood interior, Weaver used brightly colored cotton and chintz prints. Both houses used built-in furniture to demonstrate efficient conservation of functional space. The kitchen in the smaller one boasted a Murphy-type cabinet arrangement that included a range, a sink and a refrigerator, all in one modular piece. As appears to have become common practice, these homes, too, were given away at the end of the exhibition.

Reflecting the growing postwar prosperity in Southern California and the increased use of contemporary prefabricated building materials, the Fifth National Home Show displayed in the Pan-Pacific Auditorium in 1950 featured a Town and Country House that exuded a modicum of luxury, at least in its name, while introducing a more open interior floor plan. Notably, it was built of panels and featured sliding walls that could be used to either separate the dining room from the kitchen or combine the two into a flowing space. The idea of temporary partitions to open up or divide interior domestic spaces was used in the 1920s by architects Le Corbusier in Europe and by Rudolph Schindler, whose 1924 design of the Schindler-Chase home in West Hollywood included flexible enclosures of spaces through use of curtains. The 1950 show also featured the Holiday House, assembled from thirty-inch aluminum panels to reflect the sun's rays. This structure was twelve feet by eighteen feet and cost $700. It was marketed as an extra house for "town, country, or beach," with the supposition that if members of the public could not yet afford something like this, they might in the future—or at least get used to the idea of unconventional structures and materials as substitutes for roughing it in a tent. Another small demonstration structure was the Resorter, a $6,000

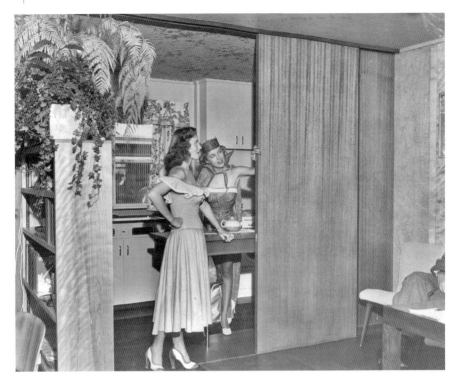

These sliding partitions of the Town and Country House, exhibited in the Pan-Pacific Auditorium in 1950, could be used to separate different functions within an open floor plan. *Los Angeles Examiner*.

one-bedroom, factory-manufactured house for resort areas. Clearly, it seems, the notions of leisure and travel were gaining traction among the postwar public.

Despite the application of industrial materials to domestic use, and despite the growing incorporation of contemporary design in home construction, rustic comfort, modern appliances and provincial furnishings were important themes for subsequent home shows. This was the age of the ranch-style house, with its informal arrangement of spaces, set in meticulously landscaped surroundings. One such house, known as the Southlander or House of Miracles, was exhibited during the Sixth Annual Home Show at the Pan-Pacific Auditorium that took place in 1951. Its exhibition publicity conflated lifestyle, gender roles and almost science fiction–like aspirations for social order. The Southlander, designed by architect James C. Young, had a shallow pitched roof with overhanging eaves and was structured around a kidney-shaped pool. Interior decoration, by Patricia Sailors of the furniture

store W. & J. Sloane, was done in a mixture of modern and provincial styles. This two-thousand-square-foot house was notable for a flexible layout plan to accommodate the changing needs of a family during its natural life span. For this purpose, and in a manner typical of California ranch-style homes, the Southlander's floor plan was divided into three zones. The so-called center zone was designed for living and entertainment and consisted of the kitchen and living and dining rooms, all of which opened through large glass walls to the patio and pool. The second zone was for the private life of the family and centered on the lanai, which—typical of this style—was seen as a key space for indoor-outdoor informal family living. The lanai could be further enclosed for use as a nursery or a children's room, a guest room, a playroom and den or as a "solarium or study for the old folks." Opening to the lanai were two bedrooms with bathrooms and a small private patio. The third zone of the house included services, such as a breezeway, service yard and the garage.

The Southlander's kitchen represented yet another culmination of scientifically analyzed workflow of household chores and was designed for the "woman who leads a busy and interesting life—the Southern California housewife." It was "stocked with time-saving accessories and machines to do the dishes, clothes, drying, meal preparation and all the multitude of other tasks that beset the modern housewife." These accessories and machines were designed to perform the tasks automatically, "permitting the housewife as much time as possible for other activities, outdoor recreation, social activities, televiewing."[8] Not to let the housewife entirely off the hook of running the house, the kitchen featured storage for fruit and vegetables, a pastry area that included a mixer storage unit and containers for bread, flour, sugar, a meat grinder and other food-preparation necessities. The cabinets, made of steel, were easy to wipe, and the countertops required no waxing and were made of resilient, long-lasting material. So as not to look entirely like an industrial site, the kitchen also had a corner wall unit with glass doors and brown-green interior to display dishes, as well as open knickknack shelves on either side of the window for added width and decorativeness.

Although home and architecture exhibitions that took place in Southern California in the period after World War II prominently promoted informal and indoor-outdoor lifestyles, the design of indoor kitchens was an important aspect of demonstration homes. Newspapers, magazines and builders' promotional literature emphasized the scientific and technological features of interior kitchen design. Americans' interest in the scientific design of kitchens goes back at least to the mid-nineteenth century. In 1846, Catharine

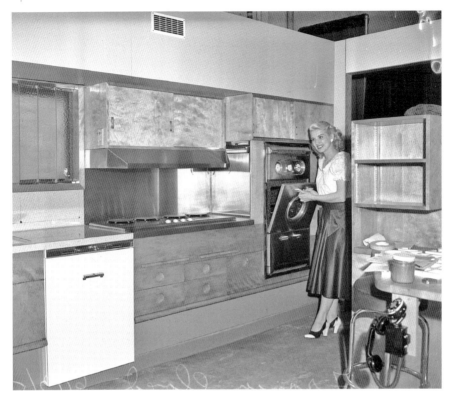

The kitchen of the Southlander, a 1951 demonstration home, had cabinets of steel and countertops that could be easily cleaned and required no waxing. Such features were advertised as freeing the housewife's time for more leisurely activities. *Los Angeles Examiner*.

Beecher published *A Treatise on Domestic Economy: For the Use of Young Ladies at Home and at School*, which she followed with an even longer-titled and more detailed *The New Housekeeper's Manual Embracing a New Revised Edition of the American Woman's Home; or, Principles of Domestic Science: Being a Guide to Economical, Healthful, Beautiful, and Christian Homes*, published in 1876. Both works were among the earliest American scientific treatises that examined and instructed women on health, hygiene, nutrition, exercise, cooking, manners, finances, charity and other aspects of upstanding household management. These manuals—framed within Beecher's belief in the democratic and egalitarian ideals of this country, as well as by her suffragist convictions—included information on the construction of kitchen appliances, as well as on the care of the kitchen. Beecher's recommendations were very specific, and some were ergonomic, all to improve the functional efficiency of the kitchen and to alleviate the burden of repetitive movements on the housewife.

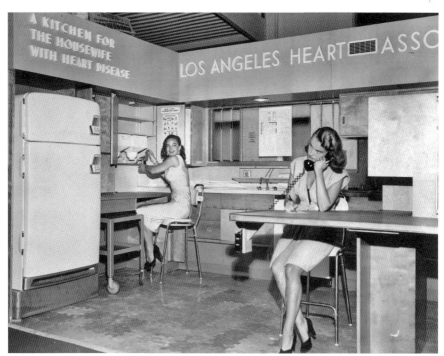

The American Heart Association's demonstration kitchens, such as the one exhibited in 1952, were popular with women in general because of their common sense arrangement of appliances and modular furniture. *Los Angeles Examiner*.

Notions of scientific efficiency in the management of daily human functions that were laid out in nineteenth-century manuals such as Catharine Beecher's and in the classics of industrial management such as *The Principles of Scientific Management*, published in 1911 by Frederick Winslow Taylor, lay the groundwork for twentieth-century ideas for productive and "logical" kitchen design that could also feature the latest materials and gadgets. Some kitchens showcased at the exhibitions were designed to address very specific needs while at the same time selling products. Among them were the Heart Kitchens, specifically laid out to help women who suffered from heart ailments. Equipment for a Heart Kitchen had lightweight modular features and was constructed for use from either a standing or sitting position, reducing the number of steps to a minimum and eliminating the need to bend down or reach up to perform common kitchen functions. In the early to mid-1950s, some studies showed that heart disease was more common among housewives than among career women, providing the American Heart Association with more reason to promote ergonomically designed laborsaving kitchens. Heart Kitchens were

also fairly compact, with supplies stored adjoining the point of use. These kitchens were also popular with housewives in general, in part because of their common sense functional design.

Demonstration kitchens were an important part of many home shows. They specifically targeted a female audience, although it was occasionally

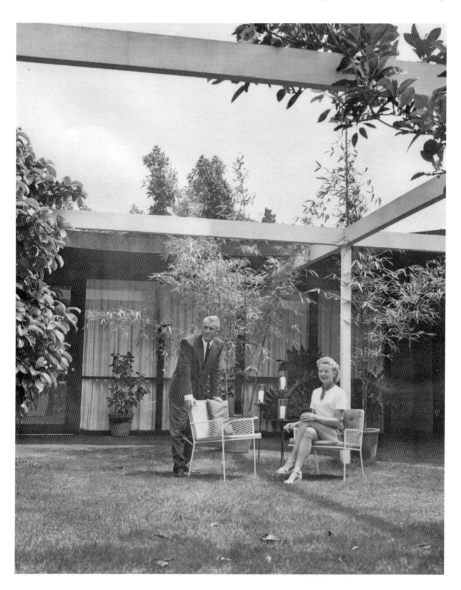

Modern outdoor living spaces and furniture framed in lightweight metal were featured in 1953 at the Pan-Pacific Auditorium. *Los Angeles Examiner*.

recognized that some men cooked, and certain aspects of contemporary kitchen design were exhibited as appropriate for both genders. Other domestic features were also modernized through the exhibitions, particularly in the 1950s. The California Living Show, organized at the Pan-Pacific Auditorium in 1953 and promoted, like all such shows, as exemplifying the ultimate in California living, both contemporary and traditional, featured a house with transparent walls instead of windows, another house with an open layout plan that eschewed compartmentalization of spaces, a demonstration of theatrical lighting readapted for use in the home and examples of outdoor living spaces and lightweight modular furniture. Popular landscaping ideas were boosted by a display of subtropical perennials, such as the pampas grass, brought from Argentina and Brazil. Subtropical plants became popular in the landscaping of Southern California homes and businesses.

The California Living Show featured a Trend Home, a 1,680-square-foot house designed as a full-scale model by Bert England, constructed by Wallace F. McDonald and landscaped by Ralph W. Smith. Together with a full-sized pool, the Trend Home display occupied over 4,500 square feet at the exhibition. The interior and exterior of this display were closely integrated in their design, and the home's overall casual California style was said to be adaptable to fit any budget. The living room featured walls decorated with walnut paneling, had a built-in radio and television and opened into the pool area. The home's notable feature was a room for informal entertainment, dubbed the Turret Room. Essentially, it was an enclosed outdoor living space. At its center stood a barbecue brazier, and a curved bar opened into an all-gas kitchen. The Turret Room was separated from the swimming pool by a glass partition and decorative bronze grillwork. This was leisure living at its best and another example of indoor-outdoor living. The Trend Home's interior was faced with timber beams and natural stone. The interior was decorated by Cannell & Chaffin in a luxurious style that could be replicated in a more affordable way by the same furniture company.

The California Living Exhibition also showed other contemporary house designs with interior décor done in functional Modernist style that included light metal furniture. The contemporary examples of exterior and interior design were set off by the more familiar styles, such as displays of Italian provincial, French provincial and Louis XV furnishings elsewhere in the exhibition. Some of the displayed new furniture integrated contemporary lifestyle needs into the more familiar look, such as a hinged night table designed to support coffee drinking and telephone conversations that could

Furniture designed for contemporary leisure lifestyles on display at a 1953 home show exhibition. *Los Angeles Examiner.*

be conducted at leisure in bed. This and other exhibitions continued in a similar style and with similar publicity to foster public taste in the California lifestyle through the 1950s.

In addition to the annual architecture and design shows, Southern California continued hosting architectural exhibitions constructed on location. These exhibitions featured work by notable regional architects and designers and functioned as both educational and fundraising mechanisms for local organizations. For example, the popular Castles in the Woods exhibition in 1954, which took place at Royal Woods in Sherman Oaks, benefitted the Children's Leukemia Hospital at the City of Hope medical facility. It featured four luxury homes designed for the exhibition by Paul R. Williams, William M. Bray, Albert Criz and Norman Hunter and furnished by Barker Brothers (for Williams), Cannell & Chaffin (for Bray) and W. & J. Sloane and Harry Gladstone (for Criz and Hunter). Cost of admission was one dollar, with proceeds going to the hospital. Paul Williams's Castles in the Woods home, which was 2,435 square feet in size, had an open floor plan, giving the interior the effect of a much larger house. Its Barker Brothers

furnishings and interior décor melded traditional and modern design through use of wood, marble, stone and glass, "keyed to the expressive oak trees" of its surroundings.[9] The home opened into an interior patio through sliding glass doors, and its sense of privacy was further accentuated by the

One of four Castles in the Woods demonstration homes from 1954, decorated by W. & J. Sloane, shows the use of a fireplace and of a partition to separate different functional spaces in an otherwise open interior plan. *Los Angeles Examiner.*

main entry being placed on the narrower portion of the site. Similar to the homes designed by Frank Lloyd Wright, the entry dramatically opened from the narrow exterior into a spacious living room. The dining area was slightly raised to overlook the living room, creating both a visual flow of space and a separation of function. The boundary between the living room and the den was demarcated by a hanging bookshelf "device" that served as a spatial divider. The kitchens were ultra-modern in all of the Castle in the Woods homes. Called New Freedom Gas Kitchens, they were supplied by the Southern California Gas Company, which had a considerable financial stake in the exhibition.

Another of the Castles, called the "House of the Years," was designed by architects Albert Criz and Norman Hunter and decorated by interior designers Shelley Thedford and A. Manners Robertson using W. & J. Sloane furnishings. It was a two-story house with a low-pitched overhanging roof, ample balconies supported by slender columns and a prominently positioned garage. Surrounded by oak trees, it exuded a sense of elegant rusticity. Its large living room space, furnished with modern yet comfortably stuffed furniture, gently curved toward the hearth. Similar to the hearths designed by Rudolph Schindler, it was one with the floor, though set off by different materials to delineate its function. The living room interior also had an open floor plan, with functional spaces separated by a raised gallery and through the use of movable partitions.

Part II

NEW SUBDIVISIONS AS PURVEYORS OF ARCHITECTURAL TASTE

As the House Beautiful and Better Homes in America campaigns to improve housing and strengthen the family as a basic social unit began to percolate to local city levels, they also contributed to the use of demonstration homes and home exhibitions that specifically promoted newly laid out housing tracts and their architectural and landscape designs. Real estate developers seized on the opportunity to contextualize planned housing as socially beneficial and as advancing homeownership. For example, in 1926, at the groundbreaking of two demonstration homes in a relatively newly incorporated Culver City, Henry S. Rosenthal, editor and publisher of *American Building Association News*, which was the mouthpiece of the United States League of Building Associations, said, "The home, like the church and the school, is recognized as one of the most fundamental of our institutions…The community with the greatest percentages of homeowners is the most stable community."[10] At the same event, Siegfried Goetze, the architect of the Culver City demonstration homes, declared that the "character of the American home will shape the future history of America in a large measure, since strength of character comes from wholesome family life. Though homes be modest they must be places of beauty." The two homes, which were financed and built by Sharethrift Community Homes and by Pacific Building and Loan for American Home Betterment, a Los Angeles–based nonprofit housing corporation, were described as having "unusual and charming features seldom found in small home buildings; [a] great aid to families of modest means [who want] to own homes which are comfortable and attractive."[11]

Although tract home exhibitions readily indicated the importance of social, symbolic and aesthetic sentiments, their purpose was primarily to help sell homes, as well as to attract additional real estate investment. Beginning in the late nineteenth century, and certainly by the 1910s and 1920s, Los Angeles was a rapidly growing city. In the early 1900s, new housing tracts were publicized as being close to rail transportation, but by the mid- to late 1920s, advertisements more often than not described how quickly one could get to the new development from downtown by car. Los Angeles and its surroundings hosted a variety of on-site home exhibitions, which were directly tied to the promotion of new tracts. Local newspapers, particularly the *Los Angeles Times*, were heavily invested in boosterist publicity on behalf of real estate interests.

Throughout much of the twentieth century, developers, architects and construction firms closely cooperated in designing and building demonstration or exhibition tract homes. These homes were open to the public and were sometimes described by developers and the newspapers as homes of the future or in other synonymous and superlative terms. The "future" had as much to do with mainstreaming new domestic technologies such as electrical or gas appliances, or with influencing tastes in interior décor, colors and furnishings, as it did with introducing new architectural ideas for the arrangement of social and private spaces. Descriptions of landscaping and of the individual demonstration homes were an important part of the publicity for new tracts. This chapter will highlight several examples of the practice of exhibiting demonstration homes in new housing developments, focusing on several just beyond the city's early twentieth-century boundary at Western Avenue and on Leimert Park.

New Windsor Square and Adobe Electric House

In 1920–21, the Tracy E. Shoults Company, headed by the eponymously named real estate developer, and its associate, builder Sidney H. Woodruff, invested in land north of their successful upscale development of Windsor Square. They imaginatively named it New Windsor Square. This was part of Shoults's and Woodruff's larger investment into developing several residential tracts to the north and northwest of Windsor Square, all of which were advertised as being among the finest residential districts in Los Angeles. In order to boost the public's interest in the new districts, as well

as in Windsor Square, Woodruff and his Western Construction Company built an expensive and luxurious demonstration house in the adobe style at 201 Larchmont Boulevard on the southwest corner with Second Street. Constructed under the direction of a man named Juan Fernandez, who had extensive practical experience with adobe construction acquired in Spain and Mexico, it was promoted as the grandest adobe structure erected in California since the middle of the nineteenth century.

The two-story, eight-room house, designed in Spanish Revival style and furnished in a combination of French provincial and Spanish Revival decorative styles, was nominally built for developer R.K. Snow. Disentangling who commissioned a demonstration house for a new tract, who owned it and who lived in it, if at all, is almost impossible. These were business investments, done through partnerships among land development firms and builders, with financial backing often provided by other associates, be it companies or individuals, many of whom did not live in the city and had no intentions of occupying the properties. The demonstration home in New Windsor Square was opened to public viewing in January 1921 and became known as the Adobe Electrical House. Sidney Woodruff said it was an experiment to showcase both an architectural style and modern household conveniences. He touted the house for its practical and artistic design and as an example of good architecture adapted to the climate of Southern California. The names of all the local builders, contractors and suppliers for the house were printed in the *Los Angeles Times*, a principal news organ that supported real estate investment and growth of the city and surrounding areas. Forty-eight thousand people came to see the house over a period of several months, marveling at the modern laborsaving electrical devices that were supposed to make the home convenient to operate without the assistance of servants. Its kitchen, which exhibited such technological novelties as a dishwasher and dryer, a buffer for polishing silver, an electric knife sharpener, kitchen aids for mixing sauces and a warmer just for baby milk, was touted as a particular example of aspirational modern living. All the rooms were equipped with electrical outlets—there were forty in all, including the garage, which contained gadgets for inflating tires, polishing cars and recharging car batteries. The comforts of the living room included an electric piano and an electric phonograph. At night, the street number was also illuminated with electricity.

The Adobe Electric House itself cost about $35,000 to construct. Electrical installations, appliances and two cars in the garage amounted to an additional $20,000. Furniture and items of interior décor represented an

extra $30,000. The overall price tag of $85,000 was far beyond the price of most conventional homes, which ranged from about $3,000 on the low end to $20,000 on the high end. Over 300,000 invitations to inspect the house were sent out, and there were weekly receptions for civic organizations, all to increase attention to Windsor Square and to New Windsor Square, which a year earlier, in 1920, was still a weed-grown field of two hundred acres. By the time the Adobe Electric House had been constructed, the streets of the tract were paved, and there were almost four hundred new homes. Despite all the publicity and attention, one of the developers, Tracy E. Shoults, purchased the completely furnished house in March 1922. He resided in it until his death a year later, in 1923. After that, the Adobe Electric House disappeared from accounts and is no longer extant. It is very likely that it did not outlive its owner by long. Adobe architecture did not gain prominence in the vernacular architecture of twentieth-century Los Angeles, and the Windsor Square, Larchmont and surrounding areas continued being developed and redeveloped for many years to come.

Los Angeles Times Demonstration and Prize Homes

In the same year, 1922, the *Los Angeles Times* sponsored the first raffle of demonstration homes, in part to increase its own subscription rates but also, and equally importantly, to steer the public toward new housing in Wilshire Crest, another new upscale development west of the city's previous boundary of Western Avenue, and to the newly laid out tract of West Hollywood. Despite the relative ease of local rail access to both Wilshire Crest and West Hollywood, automobile ownership also received a promotional push, with the newspaper announcing "twenty splendid automobiles" among its raffle prizes. To not own a car, according to the *Times*, meant being a "million miles from nowhere." Owning a car, on the other hand, meant increased happiness for the family: "For Mother—it brings the bloom of rose into fading cheeks. For Dad—it's a friendly pal, ready for work or play. For Young people—a vigorous, happy, and reliable companion."[12] Car ownership was good for real estate investment.

The top prize in the *Los Angeles Times* raffle was a newly built house, valued at $16,500, in Wilshire Crest, a district of mostly two-story homes that cost at least $10,000. As a desirable location, Wilshire Crest held a fifty-year building protection clause designed to keep apartment structures with

their transient populations out of the neighborhood. The prize house was designed in the so-called Mediterranean style by architects Mendel Meyer and Phillip Holler and was open to public inspection even while it was still under construction. "Mediterranean style" appears to have been a catchall term for an amalgam of Italian- and Spanish-influenced architectural details such as red-tiled roofs, use of wrought-iron detail and narrow decorative balconies. It also implied such spatial arrangements as inner courtyards laid out with colorful tile that often included small fountains. In addition, according to the *Times*, the Mediterranean architectural style was not only beautiful but also symbolically inspired family ties and kinship in a manner similar to the "charming villas of the sun-drenched hills of Tuscany." The Wilshire Crest demonstration home's exterior was covered in salmon color–painted plaster and had window shutters in pale green. Both hues were "so softly grayed that the effect might seem to have been wrought by the mellowing hand of Time."[13]

The home's interior was typical of the Mediterranean style as practiced in Southern California, with wood floors in the living room and bedrooms, wood beams in the ceiling of the living room and a fireplace decorated with roughly hewn stones, all giving it an appearance of a rustic villa. There was a considerable amount of wrought iron on the windows. The home's interior staircase swept up from the living room to the master bedroom, the windows of which opened to a small balcony. On a practical level, the home also boasted substantial electrical connectivity to allow for the installation of new appliances. The maid's room, which had its own bathroom, was easily accessible from the well-appointed kitchen, thus eliminating the need to have a separate stairway for servants. This prize house was definitely associated with upscale living, without being considered palatial. Its landscaping, also designed by Meyer and Holler, was laid out by the Beverly Hills Nursery. In keeping with the house's theme of a rural Mediterranean villa, its garden was a fruit plot rather than a landscaped profusion of flowers and shrubs so that it could be "lived in" as a space rather than merely contemplated visually.

The *Times*'s promotion of this prize home was in part educational, and the newspaper published several articles explaining to the general public the symbiotic interaction between the house's architecture and the landscape. While this house was not directly associated with the Better Homes in America campaign to increase homeownership, advertisements for the home used language to induce sentiments similar to those of the campaign: "Ever since the world began, the greatest endowment of human happiness

has been the HOME. To own one is still the ceaseless aspiration of those who seek things that endure."[14] The two-story house, constructed by the Milwaukee Building Company, was located on Tremaine Avenue between Eighth and Ninth Streets, overlooking Arroyo de los Jardines, or "Creek of the Gardens." The creek originated in the Hollywood Hills and flowed, several miles to the south, into Ballona Creek through the Wilshire Country Club and through Wilshire Crest near the intersection of Olympic Boulevard and Longwood Avenue. Local tourists traveling in motorcars and potential buyers were instructed to take Wilshire Boulevard to the "high ground just west of Fremont Place and Windsor Square." Developers promised that the landscaping of the new subdivision would include sunken gardens with views of the creek and recreational areas for children.

Since this was an upscale area, many lots were large enough to accommodate large gardens, tennis courts or swimming pools. Tremaine Avenue itself was planted with sterculia and acacia latifolia plants, popularized by the Pan-Pacific Exposition grounds in San Diego. The Wilshire Crest neighborhood was further promoted as being close to the recently constructed Los Angeles High School, the Marlborough School for girls and two private military schools, as well as to the Eleventh Street yellow car line. M.L. Hazzard, who was a Southern California businessman and Shriner, a volunteer for various charitable concerns and a relative of one-time mayor of Los Angeles Henry T. Hazzard, won this house, thanks in part to his relentless drive to increase the subscription to the *Los Angeles Times* and for garnering the necessary number of votes from the competition judges. It is unclear whether the new owner and his ailing wife lived in the house at all. Since M.L. Hazard was active in real estate dealings in Southern California, it's likely that he sold it soon after winning it. The house, like many in the Wilshire Crest area that were built during that time, is still extant.

The second-prize home offered was a house under construction in West Hollywood. This home was a relatively modest Spanish Revival–style bungalow, which at $8,000 was somewhat more expensive than many houses at that time and was repeatedly described to the public as picturesque. Despite the romanticism implied by this architectural style with its reference to the history of California, the house also showcased "the most modern and improved ideas in successful American home-planning."[15] It was designed by developer and builder Sidney H. Woodruff, the builder of the Adobe Electric House, and constructed by his Western Construction Company on the corner of Sherwood and West Knoll Drives. Beverly Hills Nursery did the landscaping, as it also did for the Wilshire Crest demonstration home, to

include citrus and dwarfed deciduous fruit trees, as well as tropical plants and flowers said to be in keeping with the home's Castilian character. Typical of Spanish Revival–style architecture, the house had arched openings, a tiled patio with a fountain, main lighting fixtures of wrought iron and parquet floors of different types of wood in the living room, dining room and the two bedrooms. The living room had a barrel-vaulted ceiling. The home's exterior included elements of adobe-style architecture, in essence making it an amalgam of styles.

After the daily hype about its construction, which went on for weeks, the *Times* exhibited the bungalow to the general public on August 27, 1922. In an attempt to keep this small house appealing, particularly in relation to the larger first-prize home in Wilshire Crest, the *Times* directed its description specifically to women, hyping the home's compact Hoover multi-sectional kitchen cabinetry and its breakfast nook from Peerless, which included built-in furniture. This was the latest word in modern kitchen planning, "and the house-wife is sure to become enraptured over it." The housewife was sure to also be enraptured by the latest electrical installation, which would allow her to plug in all the latest appliances. The West Hollywood prize house also featured a two-car garage. The winner of the house was E.T. Anderson, a local policeman. Although the *Los Angeles Times* did not follow up on the fate of its prize homes (the West Hollywood house is long gone), it did not have to. Both new tracts were quickly built up and populated.

Sponsoring prize homes, demonstration homes and model homes for the purposes of affecting public taste in architecture and building public interest in owning homes in newly developed tracts continued gaining steam in the 1920s. Publicity and newspaper articles addressed themselves to both potential housing investors and to those of mostly modest income means who, it was felt, should consider building or owning homes and help the city grow. This was not just a matter of generating investment into housing tracts built close to the central part of Los Angeles, such as Wilshire Crest. Thanks to the highest per capita ownership of cars in the world and to a decent inter-urban rail transportation, more far-flung developments attracted attention due to public exhibitions of demonstration homes and their sponsorship by the *Los Angeles Times*.

On July 31, 1927, the *Times* announced a new Sunday section devoted to model homes. This was a particular program that was different from the newspaper's sometimes-breathless coverage of model homes built by developers to sell property. The newspaper couched the new section as an exemplar of its leadership in the broad national movement for better

62　　LOS ANGELES RESIDENTIAL ARCHITECTURE

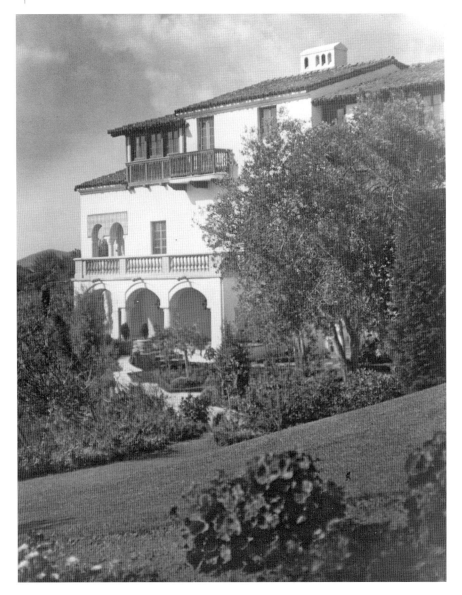

This *Los Angeles Times* model home was photographed by Harry Shur in 1930. Designed in 1928 by Mark Daniels, it is now known as Villa Aurora. *USC Special Collections*.

homes. The new section had several missions. One was to help readers and prospective homebuyers to make sense of architectural plans, existing building materials and various styles and features of furniture and interior décor. For this purpose, the *Times* also promised to provide outlines of

specifications and cost estimates. Lastly, the newspaper pledged to build a demonstration home to concretely showcase principles of efficient modern construction and effective design: "The *Times* will actually demonstrate to the homeseeker the sound reasons for everything recommended in the planning, building, equipping, decorating and furnishing of an average size model home at moderate cost."

Despite this promise, the demonstration home that was actually built was a large and rather opulent Spanish Revival–style dwelling designed by architect Mark Daniels. Located in Miramar Estates near Sunset Boulevard in the Santa Monica Mountains with views of the ocean, it formally opened its doors for public inspection in mid-1928, although there were many articles about it beginning in late 1927. This home, declared the newspaper, was not built as a model home to "boost any particular merchant's furniture or drapes"[16] but to show (yet again) how modern conveniences, artistic décor and the spatial arrangement of rooms can create an environment to support the family as the ideal social unit. The home's supposed "compact" plan was dictated by the sloping site. Both the first and second floors were arranged in such a way as to offer views of the scenery. The *Times* presented numerous construction details to educate its readership in the methods of constructing such a home on a hill slope. The demonstration house had a lumber frame reinforced with steel, was covered in stucco and had walls of a certain thickness, all giving it particular sturdiness. Its roof was made of tiles, and it had hardwood and linoleum floors, copper flashing, windows of unobstructed plate glass, et cetera. While some of its interior color was polychromatic, the exterior was painted in a light color to stave off the glare of the sun. The interior included an entrance hall, a library, a dining room, a breakfast room, a kitchen and a service pantry, a laundry area, a sunroom and chauffeur's and maid's quarters, all part of the fourteen-room count. The home's furniture was specifically designed for it and patterned in a hybridized Spanish Revival style, "modified to meet the requirements of modern Southern California," with fabrics imported from "France, Russia, Spain and Northern Quebec." The large dining room had a ceiling decorated in geometric Moorish-style arabesques of gold, green and red, and the living room had a high heavy-beamed ceiling. The home's interior décor was described in great detail in various articles.

The *Times* and the architect provided detailed floor plans to ensure that this demonstration home would not be perceived as solely ostentatious or overly elaborate but that the public saw it as an example of the perfect dwelling, where "each detail [was] worked out upon an intelligent program, each part

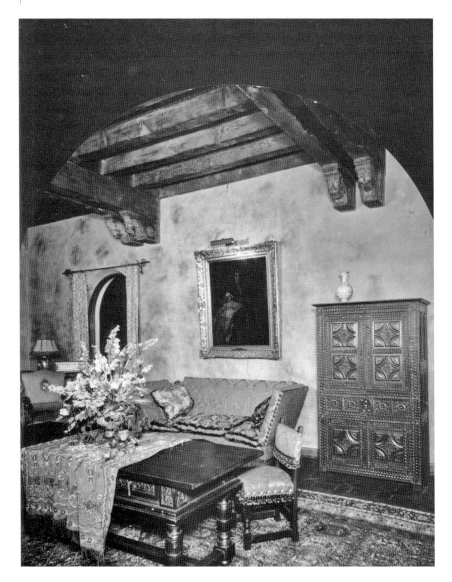

The opulent interior of the 1928 *Los Angeles Times* model home was designed in the Spanish Colonial Revival style, with fabrics and furniture imported from all over the world. *USC Special Collections*.

installed for the best reasons and each bit of material chosen because it is the best." The mission of the demonstration home was to provide inspiration and ideas to the public at large that quality details could be applied even to more modest structures.[17] Moreover, the *Times* repeatedly urged each reader

to save its articles about this house so as to develop an understanding of all the valuable information that its construction and architecture imparted.

The *Times* used the demonstration home to appeal specifically to women, whom the female columnist for the *Times* imbued with decision-making on the most appropriate vernacular architectural style for living, "where she would build the patio, if it is a Spanish type home, or if she dreams of a Colonial model perhaps the staircases have an important role in her planning as they do in every Colonial home."[18] In describing the demonstration house to the female audience, the newspaper emphasized its impregnability, saying, for example, "While the iron gates are beautiful and artistic they are built to repel anyone who seeks to enter through them." While the kitchen was extolled as having all the necessary amenities to be a cook's paradise, female readers were also directed to note the ease of circulation between various functions of the home, should they find themselves without servants: "Throughout the house there are passageways that connect rooms which eliminate the necessity of making roundabout way to them. They have been ingeniously thought out with an eye single to their convenience and practicability." The importance of the *Times*'s first model demonstration home was also framed within an educational narrative of public lectures that were given on various issues ranging from the correct use of gas appliances in cooking to the appraising of rugs for appropriate home décor. The house, purchased in 1943 by Lion and Marta Feuchtwanger, is today known as the artist residence Villa Aurora.

Home Exhibitions in Leimert Park

Many new housing tracts laid out in the 1910s and 1920s were sites of model homes and, on occasion, of housing exhibitions. Working with architects and urban planners, real estate firms emphasized a variety of architectural styles, including the more recognizable historic styles, as well as what were called Modern styles. Hybridized architectural styles emerged. They incorporated familiar vernacular elements and were easier to construct, since they required little structural innovation from the building industry. They were also easier to promote and contextualize as fitting into Southern California's Mediterranean climate. Model home and tract home exhibitions were publicized through the local newspapers. While it is impossible to enumerate all the examples of tract-based model home exhibitions that took place just

in the 1920s, a particular example of an attempt at multi-year architectural exhibition to promote investment in a new development stands out: that of Leimert Park.

In 1927, Walter H. Leimert purchased 231 acres of land from Clara Baldwin Stocker, daughter of Elias "Lucky" Baldwin. Originally, Leimert asked the firm of Olmsted and Olmsted, which had worked for him on the development of Lakeshore Highlands in Oakland, to design Leimert Park, Los Angeles's first planned community. Its boundaries were Santa Barbara Avenue (now Martin Luther King Jr. Boulevard) to the north, Arlington Avenue to the east, Vernon Avenue to the south and Angeles Mesa Drive (now Crenshaw Boulevard) to the west. Leimert initially appears to have planned to subdivide his new property into a high-end residential district and had architect and urban planner Franz Herding prepare the subdivision plans. To attract real estate and other business investment, Leimert Park was advertised as being only four and a half miles from the intersection of Seventh and Broadway Streets in downtown Los Angeles and thus nearer to the commercial center of the city than its competitor, the rapidly growing Hollywood area.

In January 1928, several new subdivisions collaborated with the *Los Angeles Times* on a House Beautiful exhibition, during which homes that were "loaned" to it by developers such as the Frank Meline Company, Sidney H. Woodruff and Walter H. Leimert Company in various locations, including Los Feliz, Hollywood, Carthay Circle and Leimert Park, were open to the public. As befitted the educational mission of the House Beautiful campaign, the exhibition's intent was to combat bad taste in design. Whose bad taste needed to be changed was not explicitly stated, although it included members of the general public and potential homeowners. However, because the subdivisions were first and foremost instruments of investment, the appeal to good taste was also intended for the builders, who had an interest in quickly selling, or at least renting, the properties.

Addressing these amorphous groups, the *Los Angeles Times* declared in an article on January 8, 1928:

> *There are so many people who build a house in slapstick fashion, buy so much furniture, so many curtains and other things that are needed, throw them pell-mell into the house and consider their work done that it will be a revelation to many to see what can be done with furnishings when properly selected and arranged by a woman who really knows how to assemble the right things in the right place.*

That woman was a Virginian named Mrs. R.H. Thomas, who worked with designers from Barker Brothers and Goodan-Jenkins Furniture Company to demonstrate taste and harmony in the interior of the House Beautiful exhibition homes, which ranged in price from a relatively modest $8,000 to the extremely high end of $40,000. Mrs. Thomas decorated the homes in regional vernacular styles, such as Colonial, English or the more nebulous "Artistic American." The overall mission was to demonstrate that good taste in décor and furnishings were important in the making of a real home, one that was not just a place for sleeping and eating. Mrs. Thomas contended that harmony in color and arrangement in furnishings contributed to an atmosphere of rest and enjoyment and assured the public that even the least costly home would be just as attractive, charming and livable as the most expensive one. Thousands of visitors were regaled with information that included technical terms for colors, draperies, woodwork, furniture and crockery.

The *Times* encouraged visitors to ask employees of the exhibition who were on hand at the demonstration homes questions related to the origins of the furnishings, the historic periods they represented, the types of materials used and the importance of certain color combinations. The exhibitors also recognized the importance of assuring the public that tasteful interior decoration could be had more cheaply so that expensive arrangements displayed in one house were adapted at a lower cost in another house. Yet another didactic element in the exhibited homes was practical, with a distinct appeal to women: "when necessary the stoves and electrical appliances can be operated to show how much many women are missing in breaking their backs and ruining their health when science and inventive skill have turned the work into pleasure for the wife and mother."[19]

Leimert Park had two demonstration homes featured in the exhibition. One of them, at 4150 Sutro Avenue, called Casita Español and the cheapest of the House Beautiful houses, boasted what were described as artistic home furnishings that did not require exceptional expenditure. Its floors were covered in tiles arranged in softly blended dull brick reds, tans, blues and grays rather than the conventional black-and-white squares. The living room was set six inches below the level of the house, which was supposed to have created a visual artistic break with the ordinary planarity of the more conventional home plans. The overall color scheme appears to have been faded tans, roses, corals and browns, punctuated with blue, jade and copper accents. This was said to be more appropriate to the overall Spanish Revival style marketed by the decorators.

Casita Español, located on Sutro Avenue, was one of two House Beautiful demonstration homes exhibited in the newly developed Leimert Park in 1928. *Dick Whittingon.*

Because the primary intended audience for the exhibited homes was composed of women, there was a considerable amount of description given to the arrangement of drapes, furniture coverings, rugs, bedding material and color accents. Casita Español's popularity, possibly explained by its affordability and by the efforts of the Leimert Company in promoting its tract development to investors and to middle-class Angelinos, was attested by the fact that over forty thousand people visited it in the span of a two-week period. The other Leimert Park exhibition home was slightly more expensive. Located farther south along Sutro Avenue, on the northeast corner with Forty-third Street, it was billed as attractive to those with more urban (presumably urbane) sensibilities. Also designed in a Spanish Revival style, it was furnished by Barker Brothers.

Although it was not the only furnishings company participating, Barker Brothers publicized its Modes and Manners furniture throughout the House Beautiful exhibition. Modes and Manners was a shop within a shop launched by Modernist designer Kem (Karl) Weber to showcase new concepts in furniture and interior décor, most of which were marketed to upscale shoppers. The shop's opening in 1926 also coincided with the first publication of a Barker Brothers magazine, called *Better Homes*, that was used to promote contemporary styles and ideas. Although Weber was educated in Germany, Barker Brothers called Modes and Manners a distinctly Los Angeles product in design and manufacturing. From the description of the

House Beautiful demonstration homes, it is highly unlikely that specific Modes and Manners pieces were used in their furnishing, since the houses appear to have reflected somewhat more conventional tastes in period décor. Nevertheless, Barker Brothers recognized an opportunity to introduce newer concepts blended with more traditional styles.

To continue enticing buyers and investors to Leimert Park, the developer invoked the romanticism of the Mexican and Californio past of Rancho La Cienega, on which former lands it was located, by giving its demonstration homes names such as Casita Español or El Jardincito. The diminutive in these Spanish names hinted at the snugness and comfort of these fairly modest single-family homes. In a modification of Leimert's original plan to make this a high-end housing tract, the Leimert Company held the first Small Homes Exhibition in early 1928, one year after the purchase of the land and the initial laying out of Leimert Park by planner Franz Herding that included plans drawn by the architecture firm of Olmsted Brothers for Leimert Plaza. In his book on the development of tract housing in Southern California, Greg Hise wrote that "Leimert's design, construction, and marketing strategies epitomized modern community planning…based on shared standards and constructed according to the most up-to-date practices."[20]

Franz Herding's street plan followed the pattern first set by the Los Angeles Railway, which formed the spine of Leimert Boulevard. Leimert Park was marked by two formal axes set at an angle to each other—that of Leimert Boulevard and Creed and Garthwaite Avenues and that of Degnan Boulevard, which met and culminated in Leimert Plaza park. According to Hise, although financial considerations were important for the Leimert Company's subdivision strategy, "[t]he precise interplay of broad boulevards and avenues, infilled with a regular, smaller scale grid of picturesque streets, created vistas leading to focal points of important buildings and functions."[21] The formal aspect of the development was also underscored by its division between single-family and multi-family dwellings. Degnan Boulevard, for example, was designed to be lined with two-story apartments and flats set close to the property lines. Leimert Boulevard also was lined with multi-family dwellings.

Ten or so structures were exhibited during the Small Homes Exhibition, with single-family ones located on Ninth Avenue and the exhibition apartment home located nearby on Eighth Avenue. The majority of the single-family homes exhibited were designed by George J. Adams and Franz Herding and ranged in size. Not all were specifically small, but they represented a range of income and investment opportunities. Each of the exhibition homes

70 * LOS ANGELES RESIDENTIAL ARCHITECTURE

This apartment building, located on Eighth Avenue, was part of the First Annual Small Homes Exhibition that took place in Leimert Park in 1928. *Dick Whittington*.

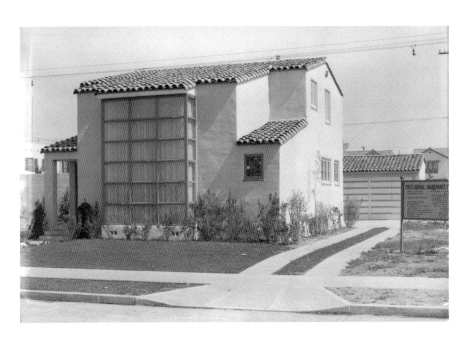

One of nine single-family homes exhibited at the First Annual Small Homes Exhibition in Leimert Park in 1928. Located next to it was a board that listed the companies that contributed to the exhibit. *Dick Whittington*.

highlighted a particular architectural and interior composition, building materials and household appliances. At least one of the houses, probably the so-called Modern Art Home, featured turquoise blue–glazed roof tiles, a rather artistic interpretation of Mexican-style architecture as compared to the more ubiquitous red roof tiles. The exhibition claimed to feature the first public demonstration of gas refrigeration and included a variety of other appliance demonstrations sponsored by the Southern California Gas Company, a major investor in the show.

A *Los Angeles Times* article from August 19, 1928, described the homes exhibited on Ninth Avenue as including a "modern art type, another of brick veneer, and a third of wood-panel construction," as well as a story-and-a-half home, all of which were supposed to contain "new ideas and innovations never before introduced in Southern California." Given the sponsorship of the exhibition, the never-before-seen innovations appeared to consist of improvements to kitchen appliances. In a later article, a *Times* corresponded explained that "[t]he modern house is a study in line and proportion; the little brick house, a study in texture…the wood-paneled house a study in scale."[22] Furnishings for the exhibition were supplied by the ubiquitous Barker Brothers, which used the exhibition in its own advertisements. Visiting the exhibition homes was free, and members of the public were admonished to come prepared to apply showcased design to "the home you are going to build. Come prepared to select the site for a home that will embody these modern ideas."[23] Indeed, the exhibit was directed as much toward those interested in investing as toward potential homebuyers. The exhibition homes, some of which remain, were in 1928 part of the initial activity to build up Leimert Park that concurrently included eighty-six homes, eight apartment structures and a market.

In 1929, as the population of Southern California continued growing despite the Great Depression, the Walter Leimert Company went on a major campaign to advertise its development to builders and investors. It linked its building and investment activities in Leimert Park to the anticipated growth in the population of the Los Angeles area and of Southern California that would result from federally funded projects in the region: "What will be YOUR share of the untold millions that will pour into the Southland as a result of Boulder Dam activities? Invest in the close-in areas of L.A. for present home or income and Future Profits."[24]

A year earlier, the 1928 Home Show had brought approximately 250,000 people to the tract, and this created an impetus for the company to promote its residential and commercial sites as "life income property"

to attract individuals and companies willing to invest. The developer stated publicly that the greatest demand in Leimert Park was for apartments, a fact indicative of the transience of the region's population and of the impact of the economic depression on real estate investors. "This smashing success" proclaimed an advertisement in the *Los Angeles Times* on January 12, 1929, "warrants immediate investigation…Only 2 individual vacancies—a cash return on every investment!" The company worked with what it called "responsible" builders to accept good equities, stocks and bonds to help finance construction. One of the builders, Charles Goldstein, who by early 1929 had built five apartment structures in Leimert Park and started work on three more, was quoted as saying, "If I could do it, I would buy every income lot for Leimert Park. Other builders don't know what they are missing!"[25]

Like many real estate companies in Los Angeles at that time, Leimert Company also emphasized its protective restrictions, which were understood as limiting certain kinds of developments that could potentially be slum-like and, by extension, warding off certain kind of people, such as non-whites or the working poor. Since at that time new tracts were still publicized in relation to their distance from the center of the city, Leimert Park was said to be a short ride on the "E" yellow car that stopped at Eighth Avenue in Los Angeles. In its advertisements throughout the year, the company published financial tables that showed how, with some down payment, an investor could realize income on rentable property in Leimert Park. As the year progressed, the company invested heavily in building rental properties, both single-family and apartment homes. In its articles, the *Los Angeles Times* cited company officials who described the difficulties with meeting rental needs quickly enough, with several hundred families already living in apartments on the tract. Publicity photographs, particularly for single-family homes, included views of the interior, such as one of the properties built by Ira McCombs, which was designed in the Spanish Revival style and included wood-beamed ceilings, interior decorative frescos and tiled bathrooms.

Builders in Leimert Park favored several revival styles, the most common being a variation on Spanish Revival. Although there was no large-scale housing exhibition in Leimert Park in 1929, some of the homes were open for general public inspection, as was common in promoting new housing developments in the Los Angeles region and elsewhere. A small demonstration home called California House, sometimes referred to as Monterey House, was exhibited on a street that was then known as Hogan Place (today Tenth Avenue south of Garthwaite Avenue). It was furnished by Barker Brothers in the Monterey style, seen as appropriate for this modest

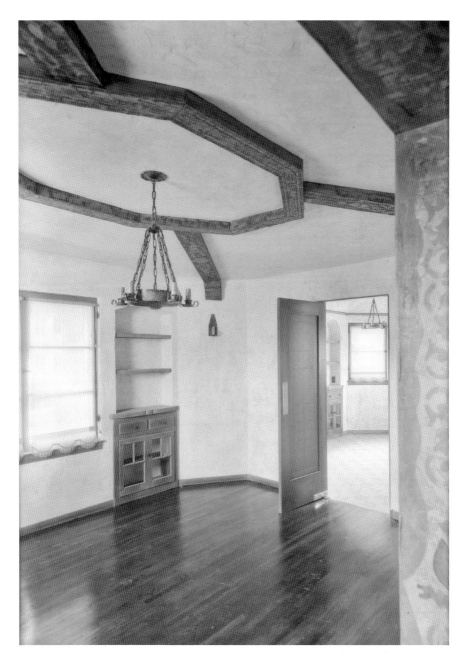

An interior designed in the Spanish Colonial Revival style in one of the investment properties built by Ira McCombs in Leimert Park, circa 1928. *Dick Whittington*.

California House was a demonstration home displayed in Leimert Park on Hogan Place (now Tenth Avenue) in 1929. It was furnished by Barker Brothers in a modestly priced décor to attract people of moderate income. *Dick Whittington*.

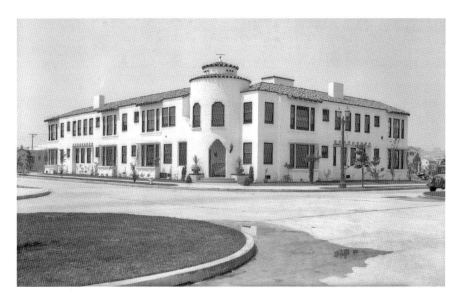

A view of the Boshes apartment building, located at 4201 Seventh Avenue in Leimert Park and photographed in 1929, shortly after construction. It was designed by Max Maltzman in the Monterrey style. *Dick Whittington*.

house. The Monterey-style furniture line took its name from a vernacular style developed in Northern California. It was used by Barker Brothers to harmonize with the home's so-called California architecture, a hybrid type of architectural idiom that was more angular, simpler and less ornamental than Spanish Revival. The term "California architecture" was rather fuzzily defined and sometimes used interchangeably with Monterey style. The latter was exemplified in Leimert Park in the architecture of the apartment house designed by Max Maltzman for David S. Boshes, which still stands on the northeast corner of Seventh Avenue and Forty-second Street.

In 1930, the Leimert Company organized another Los Angeles Annual Small Home Exposition to publicize new buildings in Leimert Park, both commercial and residential, which by this time numbered over five hundred. This exposition was somewhat more ambitious than its predecessor two years earlier (despite its name, the exposition took place twice, spaced two years apart). The stock market crash in 1929 reduced many families' incomes and work prospects. Nevertheless, the region still had people and corporations with money to invest. Like its predecessor, this home exposition was designed to generate interest in Leimert Park as a site for real estate investment, particularly in rental properties. Ten homes were designed especially for the exposition by Los Angeles and Hollywood architects Gordon B. Kaufmann, Roland E. Coate, Carl Jules Weyl and George J. Adams in collaboration with Leimert Park's planning architect, Franz Herding. They were built in a planned, carefully landscaped setting designed by Herding on Edgehill Drive, just north of Leimert Boulevard.

Thirty-five additional new homes, erected by local builders and construction companies in various locations close to the exposition area, were also open to the public. As was typical of architectural exhibitions at the time, the majority of the homes on display were designed in architecturally recognizable styles, such as Italian, Mediterranean, Spanish, French, English and early California. Among the ten houses exhibited on Edgehill Drive, Roland E. Coate designed a small Norman-French-style house, which featured a hipped roof, a trellised front door and French windows framed by shutters. Gordon B. Kaufmann designed a two-story Colonial California house, the façade of which was distinguished by an overhanging balcony that ran its length, French windows with full-length shutters and a chimney that looked like a Spanish mission bell tower.

The California theme was also picked up in the houses designed by Carl Jules Weyl, Franz Herding and George J. Adams. Weyl's two-story home, dubbed California Adaptation (although there is no such formal style), had

LOS ANGELES RESIDENTIAL ARCHITECTURE

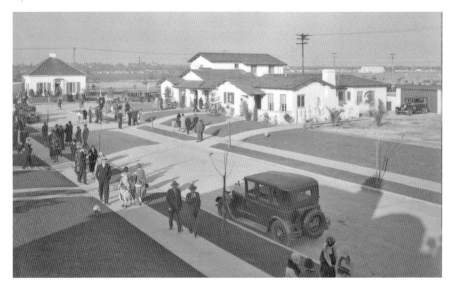

A general view of the Los Angeles Small Homes Exhibition designed by Franz Herding in Leimert Park in 1930. Seen here are homes by Roland E. Coate and Carl Jules Weyl that were designed specifically for the exhibition. *Dick Whittington.*

a cascade of overhanging tiled roofs and a front entry framed by unadorned columns. Franz Herding's two-story Monterey-style home featured a front patio delineated by a low-slung wall, a shallow second-floor balcony overhanging the front and a pitched tiled roof. George J. Adams's one-story Modern California home featured a squat rounded tower in the center, an entry partly hidden by an archway and a front porch enclosed by a stucco wall. It, along with several other exhibited homes, displayed exterior murals by painter Einar Peterson.

The other five homes on Edgehill Drive were designed in a combination of Spanish Revival and California Colonial styles by Franz Herding and George J. Adams. Although they were supposed to be innovatively constructed thanks to the new process of insulated concrete that was reinforced with steel, most featured familiar exteriors covered in stucco. Advertisements touted, rather disingenuously, that each home was "set off like a brilliant jewel by a background of trees, flowers and shrubs with plazas conceived by Olmstead [sic] Brothers, noted city planners."[26] The furniture company Barker Brothers was commissioned to furnish five of the exposition residences, for which purpose it supposedly brought some furnishings from the East Coast not heretofore seen in Los Angeles. The hype was such that Barker Brothers sponsored a series of lectures on the art of furnishing homes. The furniture

mixed and did not always match the historic revival themes embodied in the design of the exhibition homes. Thus, for example, Coate's Norman-French-style home was furnished partly in a rustic California farmhouse style, and Weyl's California Adaptation house had English-style furnishings. Potential visitors were instructed to keep in mind that this was an exhibition of small homes, which did not have to be outfitted at great expense. Some of the exhibition houses featured indoor and outdoor fireplaces, massive beamed ceilings, sleeping porches and, in at least once case, connected garages that served two homes at once.

The Great Depression affected Leimert Company's sales strategy, channeling it toward investors, many of whom—although not all—were men. Nevertheless, like many housing exhibitions, the 1930 Annual Small Homes Exposition was also marketed to housewives. One *Los Angeles Times* advertisement featured a handwritten letter addressed to the Walter Leimert Company, in which a housewife praised the model homes she visited with her husband and anxiously inquired whether any of them were for sale. To assure the housewife, the advertisement extolled the homes as being picture-perfect, modern and comfortable and available for a modest price despite being designed by notable architects usually accustomed to building costly mansions in the exclusive sections of the city. The ad's description of construction methods was just specific enough to be geared to an average reader, man or woman. Given the prevailing economic situation, Leimert Company featured advertisements that also publicized the thirty-five dwellings open to the public concurrently with the exhibition as examples of better home construction rather than as sources of profit for the developers. The importance of educating the general public was cited as the circumstance that attracted notable builders, architects and decorators to invest their time into altruistically showcasing modest homes that cost $7,000 to $8,000. Nevertheless, the importance of commercial investment into real estate was not neglected. It was merely redirected toward members of the general public and transplants from other parts of the country. One advertisement featured a Vermont couple of modest means who wanted to invest in something stable and who were steered by their financial advisor toward investment in lots and income units (i.e., rentals, particularly apartment buildings) in Leimert Park. The advertisement featured a financial chart showing how such a typical couple's modest investment in the subdivision would generate net income. Leimert Company assured potential investors that it would assist with financing and insurance arrangements. By mid-1930, the company reported that five hundred families had made their homes in Leimert Park,

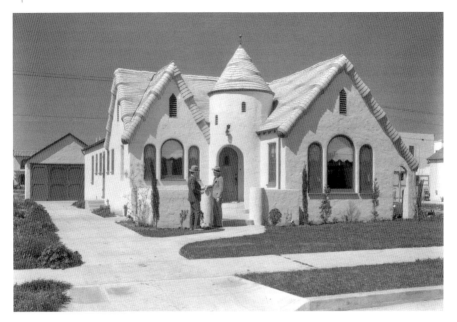

An example of a home designed in the English Revival style in Leimert Park, 1930. *Dick Whittington*.

attributing this to the attractive restrictions and architectural control of the development, which was overseen by the architectural board of the Leimert Park Community Association. The board was headed by George J. Adams, who, together with Franz Herding, continued planning Leimert Park's growth during the 1930s.

As mentioned earlier, taking advantage of the exposition and of the fact that several hundred thousand people attended it, thirty-five additional homes were open to the public. These homes, like the exposition houses, were built in a variety of common vernacular styles. A new apartment structure with twelve apartments, built in a modified Moorish style on Leimert Boulevard for investor Helen McCabe, possibly from a design by George J. Adams, was also publicized for the benefit of the exhibition-attending public. Members of the Hollywood film community were brought to view the exhibited homes for investment purposes, and local high school and vocational courses brought students to study trends in architecture, interior design and furniture displays. Barker Brothers, which furnished the exhibition homes during both Small Homes expositions in Leimert Park, promoted itself as a premier go-to company for interior design. It sponsored free citywide lectures delivered by its decorators, such as Edgar Harrison

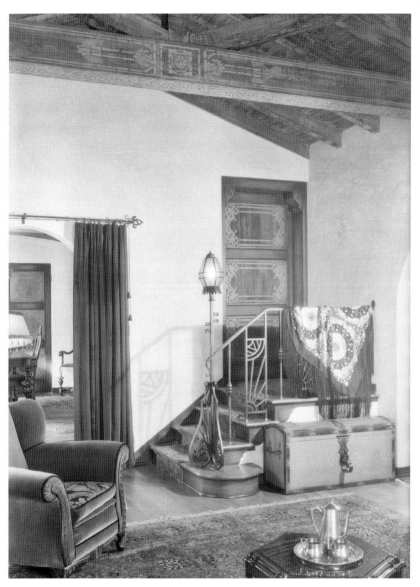

The interior of a large home built by a developer in Leimert Park in the Spanish Colonial Revival style, 1930. *Dick Whittington*.

Wileman, to various audiences, particularly those who "dwell or will take possession of houses, modest in dimensions," to help them bring interior decoration "within the realm of good taste."[27] Wileman's lectures addressed specific stylistic issues. For example, in a lecture he delivered in April 1930,

he discussed furnishing an "English-California house." In another, he discussed "informal provincial styles" in interior design. Wileman illustrated his lectures with lantern slides of homes he furnished on behalf of Barker Brothers for the 1930 exposition in Leimert Park. From 1928 to 1930, many of the advertisements by Barker Brothers and other manufacturers and building companies, such as Gladding-McBean, featured their work for the exhibition homes erected in Leimert Park.

Investment in the tract, buoyed by a continuing cycle of building single-family homes and multiple-family rental properties, continued into the 1930s. Although Leimert Company put the best face on its building activities in Leimert Park, which was not its only tract development at that time, advertising the many apartment homes being built, by whom and with what amenities, the economic depression hit hard, and the company began slashing prices, in some cases by 40 percent or more. In the early 1930s, the company's publicity concentrated on hyping the big profits that investors could get rather than on the architecture and layout of the development: "Think how many times in a year you waste a dollar. Buying property with this tiny payment per week means that you don't have to DENY yourself anything," declared an advertisement in December 1931. Rather than showing drawings of homes or apartment buildings in Leimert Park and extolling their architectural and spatial virtues, as was done in publicity during the various home exhibitions, advertisements in the 1930s featured a cash register that promised big profits now and no interest payments until a few years later. Although revival styles continued to be heavily favored, new architectural styles emerged in Leimert Park, inspired by Modernism, as may be seen in the design of the apartment building located on the southwest corner of Stocker Street and Degnan Boulevard.

As the country began emerging from the Great Depression by the mid-1930s, Leimert Company declared that it had only a small percentage of Leimert Park's properties unoccupied. After World War II, the company moved on to develop other tracts. Some were adjacent to Leimert Park, such as Baldwin Hills Village Gardens, and others farther away, in Beverlywood, Encino and other communities near Los Angeles. Many of the single-family and apartment structures built during the early years of Leimert Park, which stylistically emulated the homes displayed during the two Small Homes exhibitions, remain, forming the development's historic fabric of Spanish-, Mediterranean-, Moorish-, English- and some Colonial Revival–style architecture. Leimert Park also features several buildings inspired by

NEW SUBDIVISIONS AS PURVEYORS OF ARCHITECTURAL TASTE

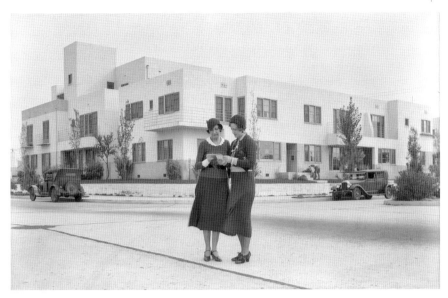

An apartment home in Leimert Park, built circa 1931 in a style inspired by the International style. The structure is still located on the southeast corner of Stocker Street and Degnan Boulevard. *Dick Whittington.*

the International style, notable for flat roofs, thin supporting columns and rectilinear volumes.

Educational displays of demonstration homes to highlight newly developing tracts continued in the Los Angeles area into the 1930s. The architectural styles of these homes appear to have been mostly revival styles, with structural features, interior décor and appliances, particularly of kitchens, highlighted as specifically modern. For example, a three-bedroom demonstration home that opened in 1934 in Moreno Highlands in the Silver Lake area of Los Angeles was built in a Monterey Colonial architectural style. The interesting feature of this home, according to publicity, was the modern treatment of the foundation and of the understructure. Another typical example was the more opulent Georgian Colonial Revival–style demonstration home that opened to promote the Beverly Green development in 1937. Furnished by May Company in an appropriate décor, its attraction to the general reader was not merely the fact that it was co-owned by film director King Vidor but also that it was equipped with certain modern conveniences, such as refrigeration, air-conditioning, a new method of insulation and a kitchen faced with monel (nickel-like) metal. Building and construction science advanced, but architectural styles less so.

World War II brought changes both to the construction industry and to public architectural tastes in single- and multi-family residences. Vernacular styles mutated, from hybridized Spanish, Mediterranean, English and Colonial revival styles to variations on the ranch style or that of the unadorned modern bungalow and incorporated exotic features, such as "oriental" or "Polynesian," brought home by the war experience. The concept of a demonstration home to promote new and expanded developments and to shape public taste continued, albeit with decreasing frequency, into the 1950s. Demonstration homes and home exhibitions on new tracts were of their time, influenced by nationwide, federally supported campaigns to increase homeownership. They provide a window into the propagation of architectural tastes and of lifestyle expectations constructed (literally) by builders, real estate developers, architects and designers of furniture.

Part III

MASS HOUSING, HOUSING THE MASSES

The Los Angeles area is known primarily as a low- to medium-density, low-rise metropolis comprising single-family homes, the spread of which was considerably aided by automobile transportation. If the East Coast skyscraper became the icon of American commerce, the suburban tract home, so typical of Southern California, was rooted in the "Jeffersonian agrarian ideal that 'as few as possible shall be without a small portion of land.'"[28] Los Angeles was platted with single-family plots, typically fifty feet wide by one hundred feet deep. Population growth figures tell one part of the story: in the century between 1900 and 2000, the population of the city went from 100,000, to over 1 million in 1930, to just under 3,700,000 at the beginning of the twenty-first century. Already by the 1990 census, some tracts had begun approaching population densities of 78,000 people per square mile, which was more or less equivalent to the average population density of Manhattan.[29]

Given the quick population growth and densification in some areas, the city also has a lengthy history of large-scale multi-family rental housing developments. Some were part of efforts by the federal government and by private investors to accommodate housing needs of a growing population of working-class families, while a few were also a product of industrial age corporate paternalism. Particularly in the 1930s and early 1940s, a considerable number of multi-family housing developments combined innovative ideas in architecture and landscape for the purposes of improving the social and economic conditions for living. Los Angeles also has a large

stock of apartment homes built to accommodate a variety of income levels. Constructed in large numbers from the late nineteenth century to the present, apartment buildings conformed architecturally to the prevailing contemporary vernacular styles. Thus, apartment and condominium living has been a historic part of the growth of Los Angeles. By the late twentieth century, with the city undergoing densification in certain areas—thanks, in part, to adaptive reuse of historic buildings to apartments and to newly built high-rise, transit-oriented developments along major rail and subway corridors—questions of architectural design, gentrification and cost of living have become part of the debate on the urban and environmental future of Los Angeles and Southern California.

Although apartment and multi-family rental living is commonly associated with populations that are transient, indigent or transitioning to single-family homeownership, none of these notions on its own adequately explains large-scale investment into constructing such accommodations in the city and surrounding areas. It is true that the history of the region's growth is intertwined with waves of transient populations that came here to work in the oil, harbor, defense and film and entertainment industries. Los Angeles and other cities in Southern California (notably Pasadena) were major health and tourist destinations, and visitors would often stay in the area for months at a time. Not everyone could afford or wanted to bear the expense of purchasing a home. In the late nineteenth and early twentieth centuries, Los Angeles was characterized by boardinghouses and residential hotels, as well as by a variety of low-rise apartment homes that accommodated new waves of population with differing lifestyle expectations and levels of income. In the early part of the twentieth century, duplexes, bungalow courts, small courtyard apartments and two-story buildings housing four units were common and were architecturally designed to give the impression of single-family homes. In the pre–World War II period, the Los Angeles region attracted immigrant populations from elsewhere in the United States and from abroad to work in its industries. The war economy became another locus for population growth. A benign climate, although given to earthquakes and to river flooding; a burgeoning population; and federal financial support for private investment into real estate developments and home building all created opportunities for construction of multi-family housing projects on large tracts of land.

An indicative, although by no means singular, example of privately financed, federally insured plans to accommodate the new populations that came to Los Angeles to service the industrial and building production

of World War II is that of Crenshaw Boulevard in Baldwin Hills. In 1947, the Crenshaw–La Brea Company purchased six hundred acres from the Anita Baldwin estate for $3 million in order to develop eight hundred rental units in eight hundred structures and to build several thirteen-story apartment homes in Baldwin Hills. A primary draw for this type of residential development were the Broadway and May Company stores that opened in 1947–48 and which became anchors for one of the earliest suburban malls in the country. Architect Allen G. Siple made plans for apartment structures of twenty units each that included single-room apartments "of a size and arrangement as to give them the facilities of a small house."[30] Although not all the plans came to fruition, to this day, the environs of Crenshaw Boulevard in the Baldwin Hills area contain a considerable number of apartment complexes from the 1940s.

Similar development plans proliferated in other parts of the city in the postwar period. This type of planning, however, was not new to the Los Angeles region, and neither was the concept of multi-family rental as a good investment opportunity. Already in 1910, the *Los Angeles Times* opined that land near the business center of the city was becoming too valuable for single-family residential development. The newspaper suggested that property owners could recoup their investments by erecting apartment buildings. This was true for Bunker Hill in downtown Los Angeles, where low-rise apartment buildings began replacing mostly Victorian homes, and it was equally true for the southwestern area of the city around Sixth Street and toward the western boundaries near Westlake Park (present-day MacArthur Park). Apartment buildings erected in the 1910s were generally two to six stories high, rising to seven to ten stories on average in the 1920s. A considerable number were luxury apartment hotels that contained two- to three-bedroom suites and various services designed to replace domestic chores for those able to pay. Others were boardinghouses that contained mostly individual sleeping rooms and sometimes offered amenities such as recreation rooms or roof gardens to their mostly single renters.

Apartment buildings did not just characterize the urban growth of Los Angeles but were also important in the development of neighboring cities. In the 1920s, as the borders of Los Angeles expanded, so did the building of apartment structures, leading to a debate within the city's business and civic communities about the future of its urban development. Some real estate investors, such as A.W. Ross, developer of Miracle Mile, foresaw a densified, high-rise Los Angeles similar to Manhattan or central Chicago. Investing in apartment buildings of any sort was brisk because such investments

constituted an ensured income base. While many investors were locally based—although not necessarily in Los Angeles itself—many others were from outside of the state. It should be noted, parenthetically, that among individual investors in income-producing housing at this time, there was a considerable number of women. Indicative of the importance of apartment buildings in the development of the city, some of the extant structures have been designated Historic Cultural Monuments for their architectural integrity and for their importance in defining the city's urban fabric.

By the mid- to late 1920s, immigration into Los Angeles was high enough that the city was facing a shortage of high-class hotels and apartment buildings, although it had plenty of the "ordinary"—i.e., low- to mid-priced apartment lodgings. This perception was partly driven by a large number of well-to-do families that came to reside in the city, at least on a seasonal basis. Apartment building architecture, particularly as seen today in historically designated structures, came to reflect the needs of upper-income families. For example, the *Los Angeles Times* quoted a builder in December 4, 1927, as saying:

> *Of late there have been wonderful innovations in the designing of first class hotels and apartment buildings. The old box-like buildings, with doors and windows of uniform style throughout, are being replaced by artistic creations that present variety in design, both inside and out. They also contain conveniences and comforts that were not thought possible a few years ago.*

The building of apartments for the well-heeled continued to be an important trend into the twenty-first century.

Apartment Building Styles

A large number of apartment buildings that were originally built in the 1920s and 1930s remain in Los Angeles. Some areas, such as present-day Koreatown and the nearby Wilshire Center, which was developed by Henry de Roulet, heir to the Pellissier family that owned land between MacArthur Park and Western Avenue, have a significant number of historic apartment structures that, to this day, define the built fabric of these neighborhoods, even as they mingle with apartments built more recently. Just like single-family

homes, architecturally they adhered to particular vernacular types. The prevalent architectural styles for the grand apartment structures built during the early part of the twentieth century were Beaux-Arts, Spanish Baroque, Art Deco/Zigzag Moderne and Streamline Moderne or some variation of these styles. However, there were also apartment buildings designed in other styles, such as Monterrey (although less prevalent in Los Angeles) or English Revival. Interior design for the well-off lodgers also followed these styles. For example, the Park Lane apartment building, located on the northeast corner of Fourth Street and New Hampshire Avenue, was designed in 1927 by Leland A. Bryant in a hybrid Spanish and Mediterranean Revival style and featured stylistically appropriate opulent interiors. What follows are particular examples of common architectural typologies, many of which can be seen in and around Wilshire Center and also in such areas as the historic core of Hollywood, in Miracle Mile and elsewhere.

The Bryson, a reinforced concrete structure still located on the northwest corner of Wilshire Boulevard and Rampart Street, was designed in 1912 by

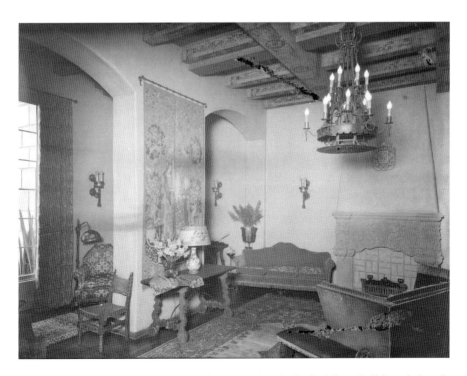

Seen in this photograph is the interior of an apartment in the Park Lane building, designed by Leland A. Bryant in 1927 in the Spanish Colonial Revival style. It is located on New Hampshire Avenue. *Dick Whittington.*

88 * LOS ANGELES RESIDENTIAL ARCHITECTURE

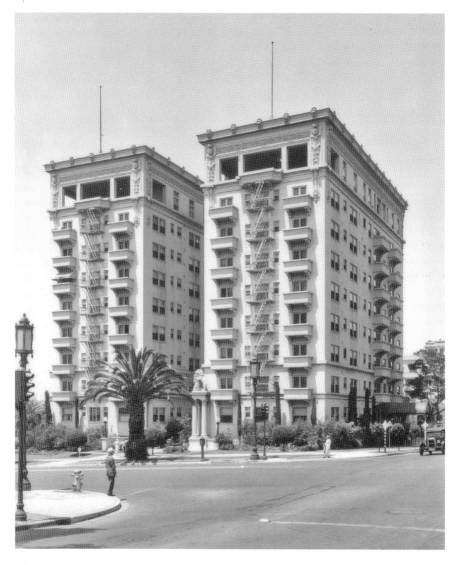

The Bryson apartment building, photographed in 1933, was designed by Noonan and Kysor in the Beaux-Arts style in 1912. It is located on Wilshire Boulevard. *Dick Whittington.*

Frederick Noonan and Charles H. Kysor for Hugh W. Bryson and constructed by the Engstrum Company. The exterior design was in the Beaux-Arts style and was originally supposed to have an imposing neoclassical concrete arch spanning both towers and resting on concrete columns. The arch was not built; instead, each of the great columns was graced with two lion figures holding shields. Another original design feature for this building was exterior

ornamentation of colored tile delineating the friezes. The Bryson was set back from the sidewalk in conformance to other dwellings, which at that time were mostly single-family residences. Hugh Bryson agreed to give up valuable frontage to landscaping in exchange for revising the building's design from six stories in height to ten in order to gain on his investment. The Bryson contained 320 rooms in combinations of single- and multi-bedroom units that numbered ninety-six apartments and suites in all. Many were designed to contain breakfast rooms, considered to be a luxury in apartments at that time. As was common to the design of upscale apartment buildings, the lobby was lavishly appointed in marble, tile and wood. The tenth floor contained billiard rooms, glassed-in loggias with views of the city and a ballroom for entertaining. Elsewhere in the building, there were quarters for maids and chauffeurs. The Bryson was added to the National Register of Historic Places in 1983 and designated as Los Angeles Historic Cultural Monument #653 in 1998.

The six-story Val d'Amour apartment building, located on the northeast corner of Oxford Avenue and present-day James M. Wood Boulevard, is an example of Art Deco, specifically of Zigzag Moderne. Its exterior is notable for a variety of cast ornamentation. Stylized male figures hold the

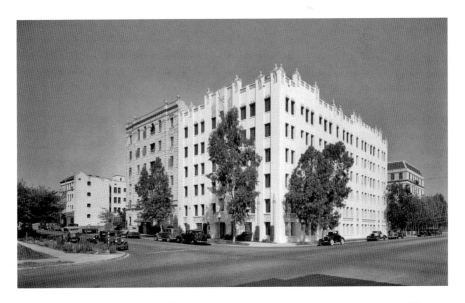

The Val d'Amour apartment building was designed by C.W. Powers and constructed in 1928 on the northeast corner of Oxford Avenue and today's James M. Wood Boulevard. To the north of it is another notable apartment building, the Villa Milan, finished in 1931 and hailed as the first furnished deluxe apartment building west of Chicago. *Dick Whittington*.

Some of the Art Deco/Zigzag Moderne decorative features of the Val d'Amour apartment building may be seen in this photograph taken in 2014. *Ruth Wallach.*

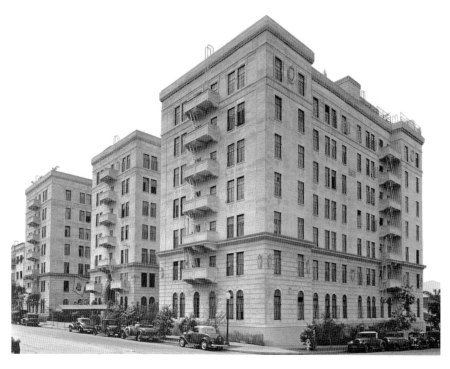

The Langham apartment hotel was designed in an Italianate style by Callahan and Sons in 1927 and photographed in 1936. It is located at 715 Normandie Avenue. *Dick Whittington.*

entablature that frames the entrance, and large human figures terminate the piers above the rooftop line. Val d'Amour appears to have been designed in 1928 by C.W. Powers, who also designed at least one other apartment building in a similar style on Hobard Boulevard, south of Eighth Avenue, also in today's Wilshire Center. Val d'Amour was designated as Los Angeles Historic Cultural Monument #875 in 2007.

The Langham apartment hotel was designed by Lee Callahan and Sons in an Italianate style similar to that of the Biltmore Hotel in downtown Los Angeles and is located on the southwest corner of Seventh Street and Normandie Avenue. It was built for investor A.W. Menkins and opened in late 1927 with four hundred rooms in 180 apartments, all with window exposure to the exterior, an important feature at a time when rooms in many boardinghouses often faced interior airshafts or had no window exposure at all. The eight-story building with walls constructed of hollow tile was considered among the largest in Los Angeles. Its towers framed two courtyards. Typical of the Italianate and Beaux-Arts styles, the Langham had minimal exterior ornamentation, although there was some decorative framing around the entrance. The windows on the first floor were designed

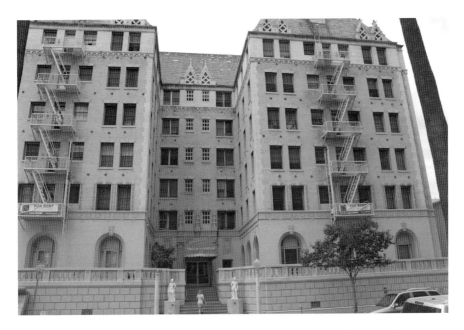

A view of the Chateau La Martine apartment building, photographed in 2014. It was designed by Max Maltzman in 1929 in a combination of styles, particularly Italian with some Moorish-inspired elements. *Ruth Wallach.*

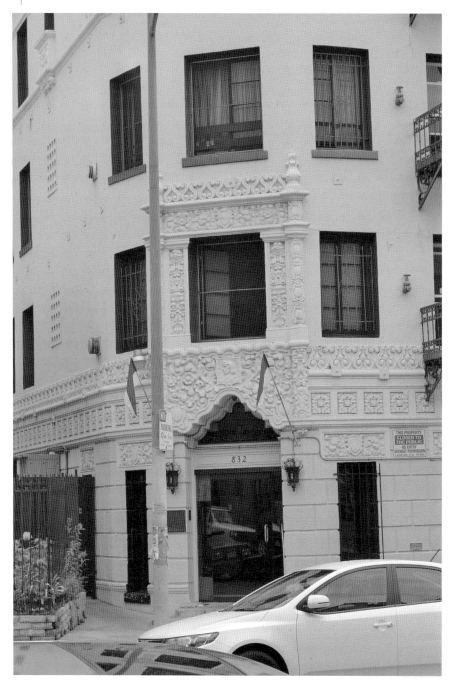

The Lovetta apartment building, photographed in 2014 and designed by Max Maltzman in 1928, displays a variety of styles, including Spanish Colonial Revival features around the main entry. *Ruth Wallach*.

to be larger than elsewhere, similar to the piano nobile windows in buildings constructed during the Renaissance period in Italy. An additional reference to Italy was that the Langham boasted a foyer designed specifically as a replica of the entrance hall of the Davanzati Palace in Florence. A special amenity was a rooftop Olympic-size swimming pool. In the 1960s, individual Langham apartments were offered for sale as part of a nationwide trend of what we today call condominium apartments.

Italianate style is the prevalent idiom of Chateau La Martine, located on Normandie Avenue just north of Wilshire Boulevard and designed by Max Maltzman in 1929. Maltzman was a prolific designer of apartment buildings and multi-family housing in Los Angeles, Hollywood and the San Fernando Valley and appears to have used a variety of styles throughout his long career. In Chateau La Martine, he employed additional architectural decorative styles to give the building a rich texture, particularly French Norman in the design of the roof and Italian and Moorish in some of the exterior ornamentation. Maltzman employed elements of the Spanish Baroque style in the decoration around the corner entrance and the first floor of his somewhat more humbly designed Lovetta apartment building, located at 832 South Oxford Avenue. Much of the rest of the exterior of the Lovetta, which was built a year before Chateau La Martine, was designed in the more plain Italianate style. Another example of Maltzman's mix of styles is the Graemere apartment building at 530 South Kingsley Boulevard, between Fifth and Sixth Streets. Constructed about 1930 with forty-four furnished apartments, it features Spanish Baroque Revival–style decoration running around the roof (considerably modified in the intervening years) and Zigzag Moderne elements elsewhere on the façade, particularly around the first floor. The building immediately north of Graemere, designed somewhat later in a Streamline Moderne style and no longer extant, was another apartment building known as the Annex; it contained fifteen furnished apartments.

Villa Serrano, a two-story courtyard apartment complex constructed in 1936, was an example of the French Norman Revival style, also known as French Eclectic. It was among the first to be built after the Great Depression, with a building permit issued to the Surety Building and Finance Company, Inc. Together with the contemporaneous Chateau Alpine located next door, Villa Serrano incorporated a French Baroque–style garden that gave each occupant a sense of living in a separate residence. Villa Serrano also incorporated neoclassical elements, particularly in the entryways that were framed by attached columns and by arched pediments that contained French-

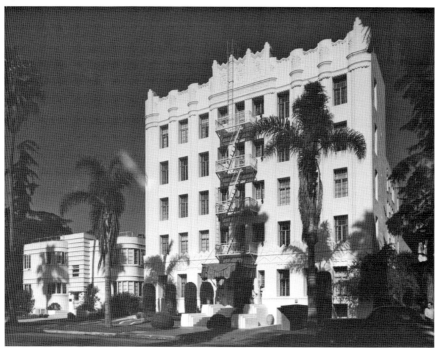

The Graemere apartment building was designed by Max Maltzman in the Zigzag Moderne style about 1930. It is located at 530 South Kingsley Boulevard. The Annex apartment building to the left was designed in the Streamline Moderne style and is no longer extant. *Los Angeles Los Angeles Examiner.*

MASS HOUSING, HOUSING THE MASSES

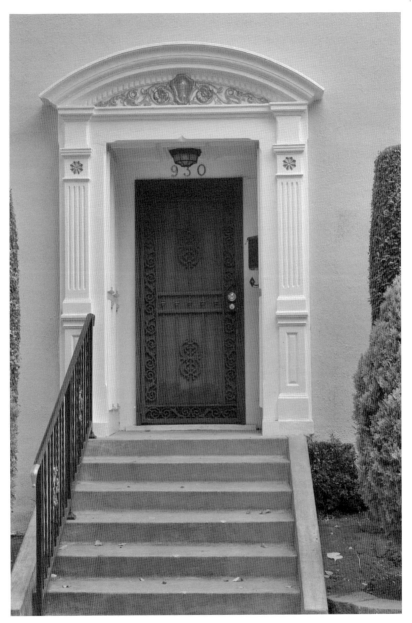

Entrances to the Villa Serrano apartments are framed with neoclassical-style columns that include some French-style scroll decorations in the arched pediments. Photographed in 2014. *Ruth Wallach*.

Opposite, bottom: The Villa Serrano apartment building was designed in 1936 in the Norman Revival style, also known as French Eclectic, and included French Baroque–inspired formal gardens. Photographed in 2014. *Ruth Wallach*.

style scroll decorations. Upon its construction, Villa Serrano was publicized as being located in Pellissier Square. This name, although generally used for the intersection of Wilshire Boulevard and Western Avenue, was employed by Henry de Roulet, a descendent of the Pellissier family and local real estate owner, to designate an area between Eighth Street to the north, San Marino Avenue to the south, Oxford Boulevard to the west and Hobart Boulevard to the east. De Roulet encouraged the building of luxury apartment homes in Pellissier Square, boasting eleven structures by 1936. Villa Serrano was declared Los Angeles Historic Cultural Monument #646 in 1998. The former Pellissier Square continued attracting apartment buildings throughout the twentieth century.

Gothic and English Revival styles also left their mark on the design of apartment buildings from the 1920s and early 1930s. The Windsor apartment hotel, built in 1927 and located on the southeast corner of Seventh and Catalina Streets, and the Piccadilly apartment building (sometimes spelled Picadilly), which opened in 1931 on Irolo Street just south of Wilshire Boulevard, were both examples of fairly eclectic takes on these styles, hybridizing them—particularly for decorative purposes—with other recognizable architectural idioms. The Piccadilly, with its sixty-four apartment suites, was designed by Milton M. Friedman primarily in the Gothic Revival style and constructed by the Consolidated Apartment Properties, Ltd. With its decorative turrets, it could have served as a prototype for the Excalibur hotel and casino in Las Vegas. Its balconies, however, were more reminiscent of the Italian Renaissance style. The Windsor also used some decorative Mediterranean stylistic details, particularly in the exterior design of the lower floors. In an ad that appeared on March 6, 1927, the *Los Angeles Times* called its architecture "ancient Tudor" with "impressive gables and a facing of varicolored brickwork, trimmed in ornamental art stone." As in the Langham building, all of the Windsor's sixty-five single and double hotel apartments were open to the exterior, an important feature for marketing purposes. The six-story building had an Italianate landscaped garden court with a fountain that paid homage to Los Angeles's Mediterranean climate.

Although much of early twentieth-century Los Angeles architecture was based on Spanish and European historicized precedents, architectural design inspired by Modernism was also influential in the design of multi-story, multi-family structures. One of many examples built in the local version of the early twentieth-century Modernist idiom, the Streamline Moderne style, was a 1936 apartment building designed by Milton J. Black and located on

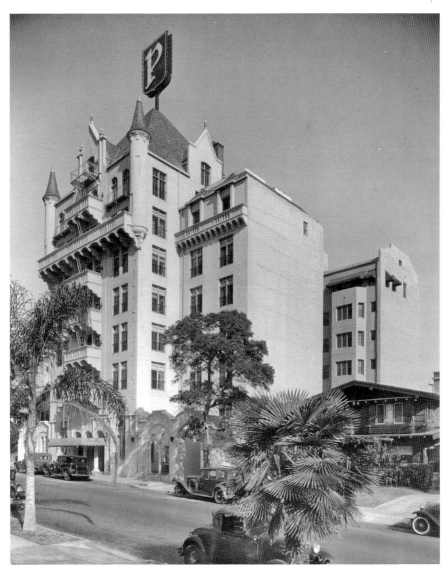

The Piccadilly apartment building was designed in 1931 by Milton M. Friedman in the Gothic Revival style. *Dick Whittington*.

the northwest corner of Hobart Boulevard and Ninth Street. According to *The Architectural Guidebook to Los Angeles*, published in 2003, "A horizontal bay once boasting a row of fins dominates the street façade. Unfortunately, the fins have been removed."[31] Milton J. Black designed a variety of single-family homes and apartment buildings in the Los Angeles area. Earlier in his career,

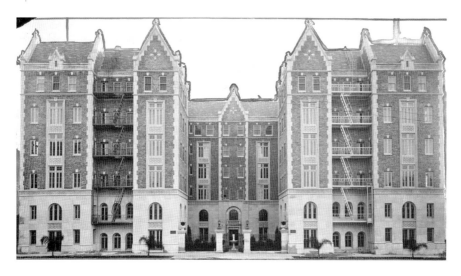

The Windsor apartment hotel, located at 3198 West Seventh Street, was built in 1927 in what the *Los Angeles Times* called the "ancient Tudor" style. *Los Angeles Examiner*.

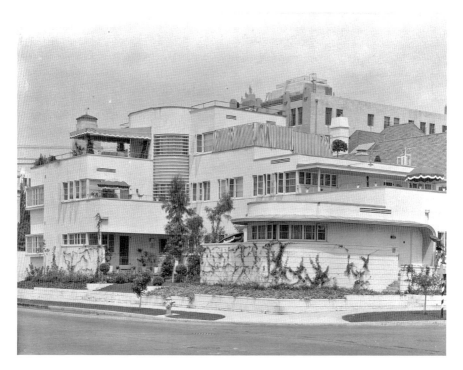

An apartment building designed in 1936 by Milton J. Black in the Streamline Moderne style and photographed here about 1938. It is located at 855 South Hobart Boulevard. *CHS*.

MASS HOUSING, HOUSING THE MASSES ✳ 99

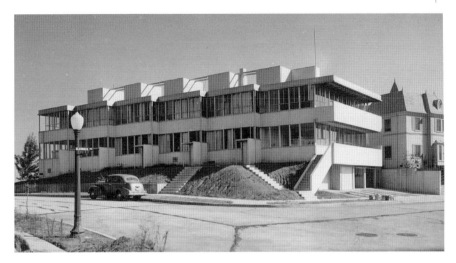

The Landfair apartment building was designed by Richard J. Neutra in the International style in 1937. It was photographed in 1938 from the corner of Glenrock Avenue and Ophir Drive. *CHS.*

he worked in a predominantly Mediterranean style, switching to Moderne by the mid-1930s, when he also worked in the Miracle Mile and Westwood areas. The International style, although not as common in apartment design in Los Angeles, was exemplified by Dunsmuir Flats, designed by Gregory Ain (Los Angeles Historic Cultural Monument #954), and by Landfair and Strathmore apartments (Los Angeles Historic Cultural Monument #320 and #351, respectively), both designed by Richard J. Neutra in 1937.

After World War II, design of apartment buildings moved away from historic revival styles. The trend was for unadorned exteriors of stucco, wood and concrete. Balconies were prevalent given the climate but not entirely ubiquitous. Apartment structures and apartment complexes continued to be built, often on the periphery of single-family housing tracts, closer to commercial streets. Many were constructed quickly and cheaply to house a population that continued growing. Notable among the more contemporary styles was the dingbat apartment, which owed its stylistic development to Modernism, particularly in its use of flat roofs and the frequent presence of slender support columns. In his master's thesis on the history of the dingbat style, Steven Treffers described the general characteristics of a classic dingbat as follows: two or three stories in height, rectangular in design, constructed of wood frame covered in stucco and rarely containing more than twelve one- and two-bedroom units. Dingbats did not have defined façades and were additionally characterized by ground-

The Hauser is an example of the classic dingbat apartment building. The defining period for this style was from 1957 to 1964. Photographed in 2014. *Ruth Wallach.*

level parking spaces in carports located at the front, side or rear of the structures. Significantly, classic dingbats had ornate signage and lighting on the street-facing front, often bearing starburst motifs, characteristic "of the space age and the country's fascination with atomic energy."[32]

According to Treffers, the defining period for dingbat apartments was between 1957 and 1964. While the term "dingbat" was used in the late 1940s to describe buildings constructed quickly and cheaply, it was popularized as an architectural designation by British architect Reyner Banham. Over the years, the term "dingbat" acquired broader usage and came to refer to large stucco, box-like apartment buildings commonly built throughout Southern California from the early 1950s onward. At the same time, many wood and stucco apartment homes continued to maintain a frontal arrangement (although not always facing the street) and developed an affinity with roadside motel architecture. Characteristic of this style were apartments arranged in long rows along exterior passageways that were reached by exposed stairways.

Toward the later part of the twentieth century, many apartment buildings in the Los Angeles region were designed to turn their fronts away from the street. Apartment structures built in the 1970s and 1980s lacked frontally

MASS HOUSING, HOUSING THE MASSES

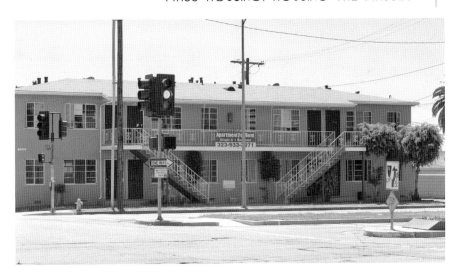

An example of a stucco apartment building that shares an architectural affinity to roadside motel architecture. Located on the southwest corner of San Vicente and Cochran Boulevards. Photographed in 2014. *Ruth Wallach.*

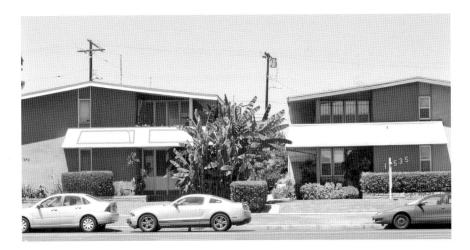

Two apartment buildings are located sideways next to each other, allowing for a greater density on the lot. Photographed in 2014. *Ruth Wallach.*

defined façades. Some were built sideways for more density on the lot; others were designed to exhibit sheer, almost bunker-like walls to the streets they fronted. Still others turned self-contained, tower-like exteriors to their immediate surroundings, especially if they fronted major transportation routes that provided quick access to the interior parking structures. On the

102 ✳ LOS ANGELES RESIDENTIAL ARCHITECTURE

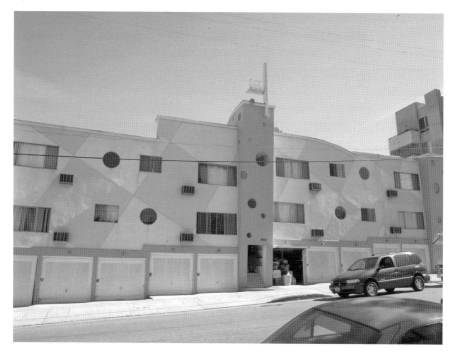

An apartment building exhibiting an almost blank wall "decorated" by some fenestration and through application of color. Photographed in 2014. *Ruth Wallach*.

cusp of the twenty-first century, thanks in part to changes in zoning that allowed for mixed-use commercial and residential development, Los Angeles began to densify in some of the more historic locations, such as Miracle Mile. With adaptive reuse accommodating conversion of old buildings to live-work spaces, the design of new apartment buildings also began to reference historic styles, often of the 1920s and 1930s.

Nostalgia for historic styles did not displace contemporary design, however. For example, new apartment and condominium buildings erected in the 2000s and 2010s as part of transit-oriented development, centering on the resurgence of public transportation, include high-rise and very large buildings designed in a variety of contemporary styles. Most have unadorned prefabricated exteriors that are massed in contrast to the often-teeming pedestrian and commercial activities on the ground. An example is Wilshire Vermont, a complex developed in 2007–08 by Urban Partners and MacFarlane Partners on land owned by the Metropolitan Transportation Authority and designed by the architectural firm Arquitectonica. It is a mixed-use development, with 20 percent of its 449 apartments designated as affordable housing, set at 50 percent of the "area

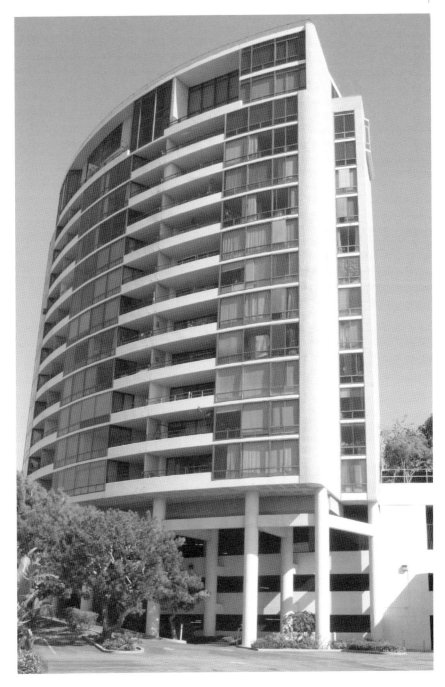

One of the towers of Marina City Club, a waterfront condominium development built by J.H. Snyder Co. in 1988 in Marina Del Rey. Facing Admiralty Way, it rests on top of a garage structure. Photographed in 2015. *Ruth Wallach*.

This apartment and commercial complex constructed on the southwest corner of Wilshire Boulevard and Burnside Avenue in the late 2000s was designed in an architectural style reminiscent of 1930s Streamline Moderne. *Ruth Wallach.*

The Vermont is composed of two glass-enclosed apartment towers situated on top of an aboveground garage and commercial structure. It was opened in 2014. *Ruth Wallach*.

Opposite, bottom: A view of the plaza in the center of Wilshire Vermont, an apartment and commercial transit-oriented development located above an underground metro station. *Ruth Wallach*.

median income." Wilshire Vermont's unadorned, almost blank façades face outward toward one of the busiest intersections in the city and inward toward a large commercial plaza that also serves those headed to a large underground station to catch the metro system's red and purple line subways. The only decorative element is a large exterior mural by April Greiman that shows a hand holding a rice bowl, which covers the entire height of the structure at the entry to the plaza and functions as a portal.

Across from Wilshire Vermont is The Vermont, finished in 2014. Composed of two glass towers that house 464 apartments, it was designed by Jerde Partnership and Harley Ellis Devereaux. The towers sit on top of an aboveground parking and retail structure. The structure, which also serves to separate the towers from the street by considerably elevating them, is adorned on the exterior by a large light sculpture shaped into an abstracted lotus flower. Designed by Cliff Garten Studios, it is titled *Los Angeles Opens Its Heart of Compassion*.

Modernist idioms, as well as homage to the region's early twentieth-century architectural legacies, abound in many recent (circa 2014) mixed-use apartment projects in Los Angeles and nearby cities. For example, two large-scale developments in West Hollywood—the Dylan, on the northwest corner of La Brea Avenue and Santa Monica Boulevard, and the Huxley, on the southeast corner of La Brea Avenue and Fountain (named after Dylan Thomas and Aldous Huxley, respectively)—display the rectangular volumetric gradations of spaces, along with flat roof overhangs and use of columns, that potentially reference the legacies of Rudolph Schindler, Richard Neutra and Welton Becket. The corner façade of the Dylan, designed by Newman Garrison + Partners, is framed by five-story-high metal "eyelashes," perhaps in a reflection on the entertainment industry or perhaps even in reference to Adolf Loos's noted "eyebrow" building in Vienna, Austria. On the other hand, perhaps this adornment is merely whimsy, referencing nothing in particular but generating speculation and curiosity.

Although the Dylan is a large structure that spreads along two busy boulevards, its street-level frontage is mostly of commercial spaces with continuous glass exteriors that give it a sense of being open to the street. A different architectural example nearby is the five-story Courtyard at La Brea, located on La Brea Avenue somewhat north of Santa Monica Boulevard. Although its street façade is essentially a rectangular structure, it displays a layered screen of bands that, despite being expressly contemporary (they have been described as layers of bandages that recall a cartoon mummy), reference the curved façades of 1930s-era Streamline Moderne architecture. The bands are coupled with perforated aluminum panels that shield the

MASS HOUSING, HOUSING THE MASSES

The 2014 Dylan apartment building, located in West Hollywood, is notable for its bright color scheme of whites, yellows, metallic greys and blues and for the metal eyelashes that decorate its main corner. *Ruth Wallach*.

108 ✳ LOS ANGELES RESIDENTIAL ARCHITECTURE

The Courtyard at La Brea, designed in 2014 in West Hollywood, is a work of contemporary architecture that references the curved lines of the Streamline Moderne style without directly imitating it. *Ruth Wallach*.

balconies that face La Brea Avenue. The Courtyard is an affordable housing complex structured around an interior garden, with each of its one- and two-bedroom apartments opening into it. Similar to other new apartment complexes along La Brea Avenue and surrounding areas, see-through glass panels run the length of the entire street-level front, with the aluminum armature forming an overhang. The Courtyard was designed in 2013 by John V. Mutlow Architects and Patrick Tighe Architecture for the West Hollywood Community Housing Corporation.

Garden Apartments and Architectural Modernism

As a ubiquitous housing typology, present since the late nineteenth century, Los Angeles's apartment buildings exhibit a variety of eclectic historic, historicized and contemporary architectural styles. Apartment design is also

noted for its assimilation of some of the characteristic of the International style, particularly in buildings from the late 1930s to the mid-1960s. The defining features of the style were codified by architect Le Corbusier and through the influential architectural exhibition that took place at the Museum of Modern Art in 1932, curated by Philip Johnson and Henry-Russell Hitchcock. Essential International-style features include freestanding support pillars (also known as pilotis), unadorned façades, open floor plans in the interior, horizontal sliding windows and flat roofs. International style was not imported wholesale as an architectural development, and in Southern California, its basic precepts were also combined with ideas of such Modernist architects as Richard J. Neutra and others.

Although this combination of modern architectural idioms is commonly associated in Los Angeles with commercial and institutional buildings, nevertheless, this stylistic development left an indelible mark on the region's residential landscape. This is particularly evident in the design of large-scale garden apartment complexes. Beginning approximately in 1937 and lasting through 1955, the Los Angeles region, both city and county, was notable for a large number of publicly and privately owned multi-family garden apartment complexes. In general, such developments were characterized by superblock site plans with interior streets and pathways that deviated from the surrounding street grid. The apartments were located in nearly identical low-slung buildings two stories in height and were designed in simple, unadorned styles. The buildings themselves sometimes exhibited minor variations, such as in the exterior design of entryways or in landscaping features. In many cases, entrances to the apartments faced common courtyards rather than streets, and the buildings were set in open spaces or green commons. In the best of the garden-style apartment projects, particularly during the earlier period before such projects became controversial, the architects consciously designed outdoor spaces to function as extensions of the interior. Parking was often placed on the perimeter of the superblocks or in nearby low-slung garage buildings, and there were recreational and common laundry facilities.

In 2012, the Architectural Resources Group published a detailed analysis of the architectural, landscape, historic and social themes of garden apartment developments in Los Angeles and the surrounding region. Its report lists thirty-three known publicly owned complexes, of which eighteen are still extant, and twenty-seven known privately owned developments, of which twenty-three survive. The history of multi-family housing tracts rests on the intersection of architectural design, landscape design and the method of financing. The federal government invested directly and indirectly (e.g.,

This aerial photograph of Aliso Village from 1946 shows the superblock and interior street plan that characterized garden apartment complexes built in Southern California between 1939 and 1955. *Los Angeles Los Angeles Examiner.*

through loan guarantees of private financing) in housing, including privately developed single-family and multi-family home projects. Nevertheless, particularly by the end of World War II, its investment into mass housing, such as large-scale apartment complexes, including garden apartments, was politically vilified by financial and real estate interests. It was also implicitly critiqued from the urban design perspective by cultural institutions, as was already evident in the 1944 catalogue of the Museum of Modern Art's exhibition *Built in USA, 1932–1944*.

The earliest garden apartment complex built was Wyvernwood, a privately owned development designed in 1939 by architects David J. Whitmer and Loyall F. Watson, with landscaping by Hammond Sadler, and constructed by Lindgren & Swinerton. Still located at 2901 East Olympic Boulevard on what is essentially a rectangular plot of seventy acres east of the Los Angeles River, its site is bisected by several curved interior streets. Wyvernwood was built to provide housing for those working in downtown and nearby industrial areas. It was privately financed by the Hostetter Estate (an early developer of Boyle Heights) and insured by the Federal Housing

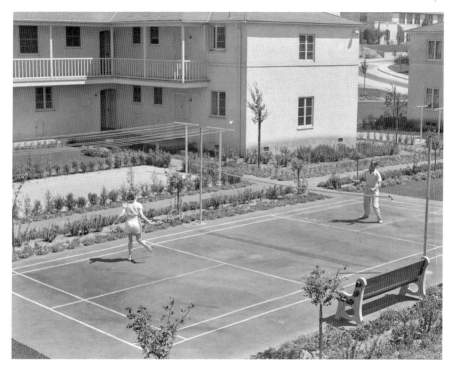

A view of a tennis court in Wyvernwood, the earliest garden apartment complex built in Los Angeles. Privately funded in 1939, it was photographed here in 1940. *Dick Whittington.*

Administration through the single largest loan guarantee made by the agency up to that point. Its long two-story, unadorned apartment structures were capped by pitched roofs, with apartment entrances defined by slim columns that supported pitched overhangs. The structures were set at ninety-degree angles to one another in an open landscape designed for low maintenance. Original plans included amenities such as sports and playground facilities. As of the writing of this book, Wyvernwood is in the midst of a preservation battle. The current owner, Fifteen Group, has proposed to replace its 143 structures, which include 1,187 apartments housing six thousand residents, with a condominium and rental development of 4,400 units; a commercial center with stores, restaurants and offices; parking for over nine thousand cars; and recreational facilities for residents.

One of the most celebrated privately developed multi-family housing projects is Village Green, designed in 1942. Prior to being renamed in 1972, it was known as Baldwin Hills Village, although initial plans called it Thousand Gardens. Village Green was designed by Reginald D. Johnson and

Wilson, Merrill & Alexander, with Clarence S. Stein as consulting architect. It was built not far away from Leimert Park on 105 acres owned by the Rancho Cienega Corporation, of which Reginald D. Johnson was president, and financed in part as a Federal Housing Administration limited-dividend rental development. Village Green fronts Rodeo Drive several blocks east of La Cienega Boulevard. Initially, its ninety-seven rental apartment structures, designed in a manner of two-story town homes with private garden enclosures, contained 627 units. The buildings took up approximately 14 percent of the development, the rest given to landscaping, leisure amenities such as tennis and croquet courts and facilities such as laundries. All apartments faced landscaped commons, giving the project a country-like appearance and, quite as importantly, emphasizing indoor-outdoor living.

Demonstrating Clarence Stein's ideal of a complete separation of automobile and pedestrian functions to maintain a green oasis for the residents, Village Green was designed as a superblock with no through streets, completely disrupting the pattern of undulating streets of the residential single-family neighborhoods around it. At the opening of the original rental units, model apartments were furnished by Bullock's Department store. Elizabeth Mock, an important American proponent of the International style and of Modernism in architecture, wrote the following about Village Green:

> *This private housing scheme is all the more remarkable when one knows the tenacity with which the FHA has fought the advantages of modern architecture and modern site-planning, time and again proven by low-cost housing. The major differences between this and the rather less costly public projects are increased spaciousness, inside and out, more extensive landscaping, individual garages and private patios.*[33]

The importance of Village Green not just for the history of garden apartment projects in Los Angeles but also as a nationally recognized example of the built and landscaped environment cannot be understated. Village Green has been listed as Los Angeles Historic Cultural Monument #174 since 1977. It was added to the National Register of Historic Places in 1993 and became a National Historic Landmark in 2001.

Another notable private garden apartment development, where both architectural and landscape design were fully realized, was Parklabrea, also known as Park La Brea and Park Labrea. It was constructed by the Metropolitan Life Insurance Company beginning in 1941 as a large

moderate-cost rental housing project on land that George Allan Hancock initially donated to the University of Southern California (USC) in 1939. This was the remainder of what was once Rancho La Brea. Metropolitan Life Insurance Company purchased the land from USC in 1940 for approximately $1.5 million and planned to invest another $13 million into construction of housing. Parklabrea was part of several programs of the federal government to boost construction of dwellings for moderate-income families. It was also the result of the California state legislature allowing life insurance companies that operated in the state to invest in moderate-cost housing developments. In developing its plans, Metropolitan Life contended that the company has long been interested in housing projects in which private capital could economically afford low-cost rentals. Parklabrea was fiercely opposed by local apartment building owners and by some insurance policy holders, and the legal battle reached the California Supreme Court in 1940, just as the company purchased the land. After the court quickly handed a ruling in favor of Metropolitan Life, the City of Los Angeles announced plans to annex this unincorporated area in order to expedite groundbreaking for construction. Work on the development began in late May 1941, at which point the city council's public works and planning committees also made provisions to extend Hauser Boulevard northward as an artery passing through Parklabrea. The ordinance annexing the tract to the city was adopted in July 1941.

During the first phase of construction, interrupted by World War II, Parklabrea consisted of thirty-one two-story garden apartments designed by New York architect Leonard Schultze in association with Los Angeles architect Earl T. Heitschmidt in a simplified Colonial Revival style. The style can be most readily seen in the entrances framed by freestanding or attached columns supporting neoclassical architraves and overhangs. The New York–based firm Starrett Bros. & Eiken did the construction. The apartment complexes were set around often irregularly shaped interior green commons. Tommy Tomson designed the overall landscaping plan for the development. Parklabrea's initial design called for 2,700 rentable units, outdoor-use facilities and thirty tennis courts set around a central recreational area. Initially, and typical of early garden apartment complexes, only 18 percent of the land was supposed to go toward housing, with the rest of the acreage providing a park-like setting.

By 1945, Metropolitan Life had succeeded in completing about half of the planned development. Foundations were laid for the remainder of the housing, as construction was temporarily suspended until the late1940s. In 1948–49, Parklabrea began expanding eastward toward Hauser Boulevard

The entrance to an apartment in Parklabrea, designed in the Colonial Revival style by Leonard Schultze and Earl T. Heitschmidt. Photographed in 2014. *Ruth Wallach*.

The early apartment complexes of Parklabrea often opened onto irregularly shaped interior commons. Photographed in 2014. *Ruth Wallach*.

and beyond, with the company financing eighteen apartment towers of thirteen stories each to the tune of about $30 million. This expansion increased the number of apartments from the initially built 1,380 to 4,400. The new high-rise buildings were designed by architect Leonard Schultze, who had also designed the earlier garden apartments, in association with the Los Angeles–based architectural firm of Kaufmann & Stanton. Garage structures were built adjacent to each of the towers. Starrett Bros. & Eiken again did the construction work. Thomas Church designed the landscaping during this phase. Unlike the older apartments on the property, all apartments in the X-shaped towers faced toward the outside. The expanded Parklabrea opened to occupancy in 1950.

Parklabrea's overall plan is based on French Baroque period pattern. Formally designed diamond, circular and octagonal shapes are connected by radiating diagonal streets. The development's grid is entirely distinct from the mainly gridiron pattern of the streets that surrounded it. In 1983, Parklabrea obtained permission from the city to close access to its interior so that today it is almost entirely gated and thus further separated from its environs.

A consequence of the American entry into World War II was the extensive development of housing for war workers, authorized under the 1940 Defense Housing and Community Facilities and Services Act, otherwise known as the Lanham Act. Southern California was a site of several government-financed temporary and permanent housing projects. In order to house fourteen thousand wartime industrial employees, particularly in the harbor area, five Lanham Act housing projects were quickly built at a cost of $13 million. One of them, Channel Heights, located near Western Avenue and Twenty-fifth Street in San Pedro, was particularly celebrated in architectural literature. Designed by architect Richard J. Neutra with consulting architect Lewis Eugene Wilson and landscape designer Raymond E. Page, Channel Heights apartments were constructed by the Baruch Corporation. The development was located on 150 acres of hilly terrain that rose 245 feet from east to west and was bisected by a 90-foot canyon and several other smaller canyons. It contained six hundred two-bedroom and a few three-bedroom apartments housed in 222 structures that consisted of one-story duplexes and two-story, four-unit buildings. The project also included an administrative building, a market-bakery, a garden-craft center, a daycare and a playground. Neutra's plan called for a relatively low density of four families per acre. Interior streets that followed the contours of the hillside connected the superblocks to the highways that rang the periphery of the development. Channel Heights's

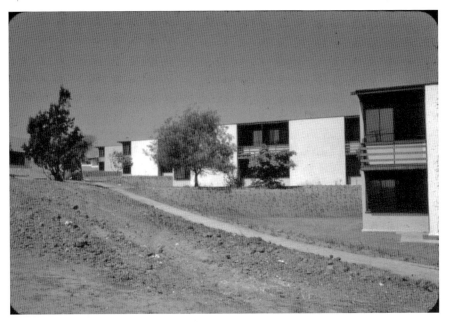

A view of the Channel Heights housing development from 1943 that shows the spatial disposition of the apartment buildings in relation to one another and to the interior paths. *Fritz Block.*

central park area branched into finger parks between each building that were bisected by gravel footpaths. Three pedestrian underpasses were planned under the highways. The apartment buildings were laid on terraced grounds, each situated at an angle to the cul-de-sac streets so as to afford clear views of the harbor for each apartment. Roofs were flat, but they sloped at an angle mirroring the rise of the hilly landscape.

The apartment buildings were constructed of pre-cut, pre-fitted wood frames that were covered on the exterior with unpainted redwood planks and cement plaster. The exterior light color scheme was in some cases offset with doors painted bright red or orange yellow. Entrances were designed at a right angle or behind a screen to provide a sense of semi-privacy. The apartments were simple and exemplified Neutra's philosophy that the landscape was as much a part of a home as its interior. Many of the apartments featured ample balconies. All units contained large windows, opening the interior into the outdoors. Interior design of the apartments was notable for its relative spaciousness and inclusion of separate kitchens, which was not always the case in some of the other rapidly constructed wartime housing. Living rooms and bedrooms had furniture designed by Neutra,

as well as wardrobes and built-in storage shelving that were described as providing more space than average in the United States. Neutra also included partitions that could be used to rearrange spaces for various needs. Neutra's notion of the permeability of indoor and outdoor spaces also applied to the planning of the communal buildings. For example, the forty- by seventy-two-foot building that housed the social hall and nursing school had glass partitions that opened it to the adjoining terrace and covered porches. Channel Heights was dedicated in November 1942, together with three other harbor housing projects: Wilmington Hall, Wilmington Hall Annex and Banning Homes. Its buildings opened to families in early 1943. Channel Heights won an Honor Award from the Southern California chapter of the American Institute of Architects for its design.

As has been well documented elsewhere, after the end of the war, the U.S. government came under considerable pressure, particularly exerted on and through Congress, to dispose of federally funded mass housing projects, including those built for wartime workers and veterans. The primary political argument was that housing projects were emblematic of socialist practices. Instead, the government was urged to redirect funding toward GI loans to help purchase single-family homes in the newly developing

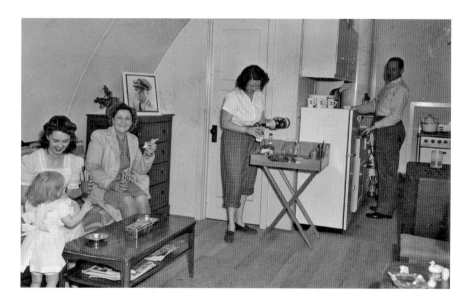

The interior of a Quonset hut in San Pedro showing the close living quarters in the emergency housing constructed to accommodate the many families that came to Southern California to work in the mid-1940s. Photographed circa 1946. *Los Angeles Los Angeles Examiner.*

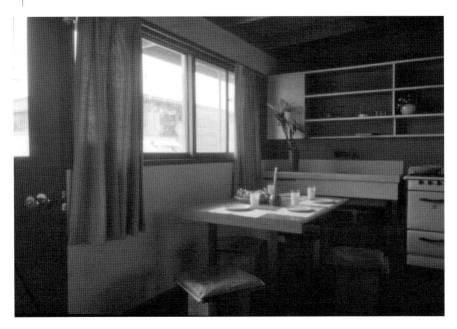

A small kitchen in a Channel Heights apartment displays a considerable amount of storage space both above and below the sink. Photographed in 1943. *Fritz Block.*

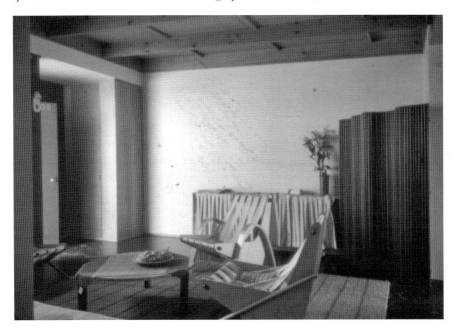

A Channel Heights living room with furniture designed by Richard J. Neutra and photographed in 1943. A partition, seen to the right, could be used to separate discreet spaces for various functions. *Fritz Block.*

suburban tracts. In late 1948 and early 1949, the federal government began negotiating the sale of Channel Heights, as well as several other federally owned housing projects, to mutual associations composed of tenants. After the Channel Heights mutual homeownership corporation failed to come up with the necessary funds, the government began considering sale to private developers. Nevertheless, in early 1949, the city council began negotiating the purchase of Channel Heights in order to ensure housing for families of veterans. Negotiations between the federal government and the city over this and other veteran housing projects continued into early 1950. Later that year and into 1951, the Los Angeles City Housing Authority took over the operation and maintenance of wartime worker homes, turning Channel Heights into housing for those earning substandard wages.

As wages continued increasing in the post–World War II period, few families remained in Channel Heights. In the early 1950s, the project's housing units were occasionally turned into temporary living quarters for navy men who transferred from other places. In early 1955, deciding that it could no longer support low-rent veteran housing, the City Housing Authority put Channel Heights for sale and made plans to relocate the remaining 263 low-income families. As justification, the city cited the fact that lower-income families were too large to live in Channel Heights's mostly two-bedroom apartments. Concurrently, the San Pedro Chamber of Commerce sought unsuccessfully to persuade the U.S. Navy to take over Channel Heights. The *Los Angeles Times* carried an advertisement of the offering by the Los Angeles Housing Authority of this "beautifully landscaped" residential development overlooking the Los Angeles River, not forgetting to mention that it was designed by a well-known architect. Channel Heights, which appears to have cost the federal government over $3 million to construct and maintain and which was in need of at least $650,000 in repairs to bring it to code, received thirty bids, ranging from $190,000 to $876,987. The city's housing authority voted to go with the sale to private interests, despite the Federal Housing Administration's request to reject all bids until Channel Heights was reappraised. Eventually, Channel Heights was demolished and replaced by other residential developments.

The architectural language of the International style, although never adopted wholesale as an idiom for housing in Los Angeles, is evident in the design of Channel Heights, particularly in the use of slender columns to support stairs and roofs and in the inclusion of bands of windows. Richard Neutra designed flat roofs for his buildings—another hallmark of the style—although in the case of Channel Heights, at least some of the roofs were gently sloped, depending

on the location of a particular building. Slightly sloping roofs may have also been Neutra's intent in his unrealized plan for the Elysian Park Heights housing project designed for Chavez Ravine. Typical of Neutra's work, this proposal also featured simple, unadorned exteriors that nevertheless provided a sense of privacy through use of enclosures and, possibly, of landscape elements. A different example of combining contemporary architectural styles may be seen in Paul Williams's drawing for the Compton Imperial public housing development, which was built in 1955 in Watts at 1590 114th Street and is now known as Nickerson Gardens. The drawing shows blocks of Modernist two-story apartment structures with some one-story apartments attached to the sides of each block. Of note are ribbons of large windows, entrances sheltered by flat overhangs and slightly inclined flat rooflines. The drawing also shows proposed landscaping by Ralph Cornell and a motor court near what appears to be a large communal or commercial building that forms a cul-de-sac.

Garden apartment projects became denser as the 1940s progressed, particularly in privately funded developments, which became more prevalent after the end of World War II. Density also became more common in postwar publicly funded housing. Privately developed garden apartment complexes built near Crenshaw Boulevard in the Baldwin Hills area exemplified this trend. For example, Crenshaw Village, a privately funded development of 1,200 apartments in 104 buildings in Baldwin Hills (at 4220 Santa Rosalia Drive) and completed in 1948, was composed of 8-, 12- and 16-unit

Richard J. Neutra's circa 1952 proposal for Elysian Park Heights housing featured unadorned façades that also offered private enclosures for each apartment. The project was never built. *Los Angeles Los Angeles Examiner.*

MASS HOUSING, HOUSING THE MASSES

A drawing by Paul Revere Williams of proposed housing for what is now known as Nickerson Gardens shows the relationship between various elements of housing and public architecture. *Los Angeles Los Angeles Examiner.*

apartment structures, compared to smaller units of two to four apartments more typical of earlier projects. Initially, Crenshaw Village was publicized as offering unfurnished private "garden-type" home apartments "painted in beautifully blended color schemes" and conveniently located near the Broadway and May Company stores that had recently opened on Crenshaw Boulevard. The apartments had one or two bedrooms and separate dining rooms and included stall showers and laundry rooms, amenities that were used as marketing tools to appeal to renters. Similarly, the 1948 Fairfax Park Apartments, designed by Hiram J. Hammer and built by Hamer and Yuna Howard to include 428 units on twenty-four acres fronting Jefferson Boulevard about a mile west of La Brea Avenue, contained 52 two-story buildings with 4, 8, 10 and 12 one- and two-bedroom apartments.

The housing blocks of Fairfax Park were designed in *L*-shaped wings with unadorned exteriors. They featured many windows, some of which wrapped around the buildings' corners, and slightly hipped roofs. Typical of garden-style apartment developments after the war, the apartments contained no balconies or semi-private garden enclosures like those that made Village Green and Channel Heights such distinctive examples of private and public garden apartment planning. Instead, façades opened to lawns that were bordered by the wings of the building. Tall trellis-like slender columns extended all the way to the roof both for support and for a sense of semi-privacy, especially as seen from the street. Main entries into the buildings were capped by horizontal architraves supported by slender columns, which in some cases formed porch-like areas. Upon the opening, Fairfax Park's model apartments were furnished by Bullock's Home Store.

This view of the Mar Vista Gardens public housing, designed in 1954, shows how landscaping was used to contextualize individual apartments. Photographed in 2014. *Ruth Wallach.*

Garden-style apartment complexes continued to be built into the mid-1950s. Their architecture and landscaping was replicated with little variation throughout and became part of the architectural fabric of Los Angeles and nearby cities. There is perhaps more than a semantic difference between the postwar garden-style apartments and the prewar garden apartments. Certainly in the later period, the design was simplified and became more conventional, with the landscape functioning as attendant to the buildings rather than as offering a spatial arrangement for living. The latter was still evident in the 1954 Mar Vista Gardens public garden apartment complex designed by Albert Criz, with landscaping done by the firm of Eckbo, Royston and Williams. Visible to this day are landscaping and architectural features that set off individual apartments within long two-story building blocks. This more individualized relationship between exterior and interior all but disappeared, particularly in the privately developed projects that tended to homogenize architectural and landscaping features.

In 1950, architect Max Maltzman designed a garden-style apartment complex near the Susan Dorsey High School on behalf of an investment group called Chesapeake-Rodeo Apartments, Inc., headed by Herbert

Kronish, a prolific builder in the Los Angeles area. The group's members also invested in other large real estate and commercial projects in the city under different incorporations. The triangle-shaped, twenty-two-acre site selected for the $3.5 million complex was bounded by Rodeo Road, Santa Barbara Boulevard (now Martin Luther King Jr. Boulevard) and Chesapeake Avenue. Chesapeake-Rodeo Apartments, at 4803 Rodeo Road, consisted of twenty-three two-story buildings constructed by the W.E. Robertson Company and housed 424 one- and two-bedroom apartments.

According to Maltzman's plans, the buildings were supposed to occupy a quarter of the development; the rest was to be given to landscaping. At opening in mid-1951, the model apartments were furnished by the Broadway store on Crenshaw Avenue in a budget-conscious eighteenth-century style that consisted of overstuffed furniture in mahogany wood and fabrics of brown and green hues. The buildings were described as constructed of a combination of stucco, brick, redwood and glass. These materials were considered exemplary of modern architecture and became standard in mid-twentieth-century apartment construction. Entrances into the multi-apartment buildings were either placed under balcony overhangs or were framed on the sides by slender columns that supported flat-roofed pediments. The Chesapeake-Rodeo complex was, similar to some of the previous such developments, trumpeted as being one of the largest apartment projects. In the age of proliferation of standardized mass-produced housing amenities and features, the apartments were advertised as having balconies and canopies, although many did not, as well as gas kitchens, garbage disposals, tile-stall showers, electric bathroom heaters, closets, wall furnaces, oak floors and television outlets. Landscaping consisted of lawns and shrubbery, with some flowers and trees. The apartment buildings had "quiet corners" for adults and were equipped with play areas for children.

At the same time as the Chesapeake-Rodeo Apartments were in the process of being built, building permits were issued for Hollypark Knolls, another garden-style apartment complex designed by Max Maltzman and constructed by W.E. Robertson Company for a group of investors, some of whom also invested in Chesapeake-Rodeo. Hollypark Knolls was planned for a twenty-one-acre site on Crenshaw Boulevard between Arbor Vitae and Ninetieth Streets in the neighborhood of Morningside Knolls. Preceding it was an eighteen-months-long legal battle between Hollypark Knolls, Inc., and the Inglewood Citizens Committee, Inc. The latter was an organization of Morningside Park single-family property owners who opposed the development of this tract for fear of plummeting residential property values.

124 | LOS ANGELES RESIDENTIAL ARCHITECTURE

The Chesapeake-Rodeo garden apartments were designed by Max Maltzman in 1950. Unlike some of the earlier privately funded complexes, this project was denser and had minimal landscaping. Photographed in 2014. *Ruth Wallach*.

After losing in hearings before the city planning commission and the city council, Inglewood Citizens Committee, Inc., took its case to the California Supreme Court. The court denied the committee's effort to reverse the city council decision that approved a zone variance for the project.

Almost as soon as the court's decision was announced, work began on the twenty-two apartment buildings containing one- and two- bedroom units, for a total of 384 units. Max Maltzman prepared thirteen different exteriors, all modern and unadorned in design, featuring the by now familiar combinations of stucco, redwood, brick and glass. Entrances to the apartment structures were located underneath flat pediments attached directly to exterior walls. Like the Chesapeake-Rodeo Apartments, which were under construction at approximately the same time, the Hollypark Knolls investment also totaled $3.5 million and was similar in size. More than half the property was allocated to landscaping, with 20 percent devoted to apartment buildings and 15 percent to services such as garages, common laundry areas and maintenance facilities. Maltzman's plan included a landscaped median that separated Hollypark Knolls from Crenshaw Avenue and a park with a variety of public and sports amenities, which was eventually laid out to the west. In what was by

MASS HOUSING, HOUSING THE MASSES 125

This 2014 photograph shows the two- and one-story apartment structures at Hollypark Knolls, designed circa 1950 by Max Maltzman for a group of investors. *Ruth Wallach.*

Typical landscaping at the Hollypark Knolls development is seen in this 2014 photograph. *Ruth Wallach.*

now a familiar pattern, apartment structures opened into green lawns bordered by trees and shrubs.

Hollypark Knolls was among the last of the privately funded multi-family housing projects to be approved for financing in Southern California under Title 608 of the National Housing Act. Beginning in 1954, several investment companies responsible for securing funding for some of the garden-style apartment complexes, including Hollypark Knolls and Chesapeake-Rodeo Apartments, came under investigation for receiving Title 608 loans that greatly exceeded the actual cost of construction and for distributing the financial windfall from these loan schemes among investment company stakeholders.

Goodyear Gardens Company Town

Single-family housing tracts and various types of apartment developments were typical ways for housing the masses in the Los Angeles area. Company-built worker housing, another type of mass housing, was uncommon in this region. Nevertheless, there is at least one example—a project from the 1920s that partly survives in the southern area of Los Angeles. The city's initial suburban growth came at the expense of agricultural and pasturelands. As was described earlier in this book, in the early part of the twentieth century, Los Angeles rapidly expanded westward, but it also expanded southward, into farmlands and garden tracts there. The Boettcher brothers, who were based in Colorado, were among those who, in the 1880s, purchased mostly agricultural land bordered to the north by today's Jefferson Boulevard in anticipation of eventually developing it. The part of their tract bounded by Thirty-first Street and South San Pedro Street was subdivided in 1903 for residential use and rapidly built up. That same year, the City of Los Angeles purchased another twenty acres from the Boettcher estate for a park that was supposed to be called South Park. It was to be located just north of Fifty-first Street at South Park Avenue, the latter renamed to Avalon Boulevard in 1926. The park, the purpose of which was to spur residential growth, was never laid out. However, as elsewhere in the city, real estate ventures did not need a park to succeed in their intent to rezone land for commercial and residential construction.

Beginning in the very early part of the twentieth century, relentless suburban development quickly continued south of the city. Already by 1905,

various real estate companies were transacting tract sales along South Park Avenue, subdividing them and placing them on the market for a variety of commercial and residential uses. Suburbanization was partly aided by the presence of large popular entertainment venues that could be reached by conveniently located public rail lines. One such venue was the Ascot Park Race Track, built by Henry E. Huntington and Associates and located southeast of the intersection of Slauson Boulevard and South Park Avenue. The racetrack, known for its horse and automobile races, operated in this location from 1905 to 1919, after which it moved to a different location farther south. Huntington's own Pacific Electric and Los Angeles & Redondo rail lines carried passengers to Ascot Park to watch the races. By the early 1920s, almost immediately after the racetrack had moved to a more southerly location, developer Charles B. Hooper began laying out eight hundred acres for what he initially called South Park Gardens. The acreage was located just south of the former Ascot Park, between Main Street to the west and Central Avenue to the east, close to the newly established Goodyear Tire & Rubber Company factory and the industrial areas in the towns of Vernon and Torrance. As enticement, Hooper offered free excursions to what he called the "Akron of California," where he promised potential investors half-acre-sized improved city lots conveniently located next to the Goodyear factory, good schools, excellent car service and still superb views of the pre-industrial landscape. Concurrently, in the mid-1920s, the city extended Avalon Boulevard south toward the harbor, and much of the remaining agricultural land was quickly subdivided and built up.

In 1919, the Akron, Ohio–based Goodyear Tire & Rubber Company selected the old Ascot Park Race Track property for its first Southern California plant, hailed by Los Angeles boosters as the biggest industry of its kind in the West. Goodyear initially purchased 580 acres on which to erect its rubber- and tire-producing factory. In addition to the factory, Goodyear also planned to construct homes, commercial establishments and park amenities, all within walking distance for its Southern California employees. Goodyear's idea of a city within a city was not unique to its Los Angeles site. Several years prior to its westward expansion, the company had developed Goodyear Heights, a 350-acre site in Akron, Ohio, located near its plant there. Local architects George H. Schwan and Warren H. Manning designed several types of single-family homes for standard lots sized at 50 feet wide and 115 feet deep. By 1918, Akron's Goodyear Heights contained over 1,500 homes built or under construction, sold to the company's employees at cost plus 6 percent on a payment plan consisting of two mortgages, one

carried by a major life insurance company and the other by Goodyear. The company went to considerable length to ensure the availability of home mortgage plans because of the strong belief held by its management that homeownership was a means to a stable society. Its paternalistic approach was summarized in a statement by its president as it appeared in the *Los Angeles Times* on December 21, 1919:

> *We believe that every family man should be encouraged in home ownership… but we discourage his buying a more expensive one than he can pay for out of his earnings…It is a fact not to be disputed that the home-owners of any city make its most responsible and valuable citizens. Much of the present-day unrest is due to the fact that more men and women prefer to squander their earnings rather than invest in property. I believe that one of the first and most necessary steps in the direction of material success lies in the direction of home ownership.*

Goodyear's Los Angeles worker housing site was to be located just north of the factory and was tentatively called Goodyear Gardens. The company promoted a plan that was more elaborate and artistic than that of Akron's Goodyear Heights and that took advantage of Southern California's mild climate for landscaping and for outdoor activities. According to a preliminary design, there was to be a broad boulevard extending diagonally from the corner of Slauson and South Park Avenues on the northwest side to the corner of Central Avenue and Sixty-first Street to the southeast. Semicircular streets and walkways planted with shade trees and semi-tropical plants were to radiate from it. In addition, the company planned a park, an athletic field, a school, a library and stores. Landscaping plans were prepared by Pasadena-based landscape architect Paul Thiene. The design for the homes to be sold to Goodyear employees was prepared by the Los Angeles–based firm of Sumner P. Hunt and Silas R. Burns. These plans varied somewhat over time. An initial plan included twenty-four bungalow court units to be built of either poured cement or cement blocks with white-plastered exteriors and clay tile roofs. The company wanted its worker housing to be indestructible yet architecturally attractive. The planned bungalows were rectangular, with flat rooflines, arched entryways that enclosed small porches and front windows shaded by overhangs. Somewhat later, Hunt and Burns developed plans for one- and two-story dwellings of brick and hollow tile, with exteriors in French, English, Colonial and Spanish Revival styles. Similar to the Ohio Goodyear Heights plan, only employees of Goodyear were to be invited to

purchase these homes at cost plus 6 percent to cover engineering overhead. In a manner similar to the Akron mortgage plan, employees could carry two mortgages, one through a large life insurance company and the other through Goodyear itself.

Despite its belief in homeownership as a stabilizing social influence and its grand plans for an eighty-acre city within a city that was so readily announced in 1919, by July 1920, Goodyear had suspended the development of Goodyear Gardens. Of the proposed eight hundred single-family homes designed by Hunt and Burns, forty-eight were built in 1920 on a stretch of East Fifty-ninth Place between Avalon Avenue (at that time called South Park Avenue) and San Pedro Street, just northwest of the Goodyear tire factory. An additional home was constructed somewhat later in 1924, bringing the total to forty-nine dwellings. Possibly, these homes were erected for the families of the fifty builders who were supposed to be brought in to construct Goodyear Gardens under the supervision of the company's engineers. Many of the homes are still extant, although quite a few have been modified in the intervening years. They were sized between 900 and

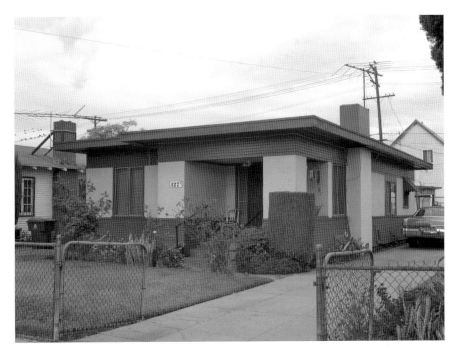

This single-family home, built circa 1920–21, was designed in a modified Prairie style for the proposed Goodyear Gardens development. Photographed in 2012. *Ruth Wallach.*

The façade of a Craftsman Bungalow built circa 1920–21 as part of the plan for Goodyear Gardens. Photographed in 2012. *Ruth Wallach.*

1,000 square feet and built on regular lots that were 50 feet wide and 105 feet deep. East Fifty-ninth Place was a relatively wide and straight residential street, probably designed in this way in anticipation of public transportation that would carry employees to the Goodyear factory and elsewhere. The rest of Goodyear Gardens was never built. In 1922, the DeWitt-Blair Realty Company acquired several lots of the Goodyear residential property and rapidly sold them to other brokers for commercial and residential developments unrelated to Goodyear Gardens. In 1923, Goodyear Tire & Rubber Company, which was experiencing financial problems, sold the rest of the lots in order to pay dividends on its stock. Photographs from the 1930s and the 1950s of this area show ordinary landscaping with a few trees and unfenced yards. It thus appears that Paul Thiene's landscaping themes were also not carried out.

The worker houses, although modest, were constructed in one of three styles: Craftsman Bungalow, Tudor Revival and a modest adaption of the Midwestern Prairie style, the latter unusual for Los Angeles and Southern California. Almost all of the houses had plain façades, although some of

the Craftsman bungalows included decorative wood frames under the eaves. Each of the standard lots also had space for a garden and a small garage.

During the 1920s and 1930s, residents of this part of southeast Los Angeles consisted of Caucasians, many of whom (at least the men) were either employed by Goodyear or in the commercial and industrial businesses nearby. Starting in the late 1940s, African Americans began moving in; already in 1948, the Goodyear factory employed three hundred African American workers. By 1980, at least 30 percent of the residents were Hispanic and around 65 percent African American, with percentages more or less reversed twenty years later. Similar demographic changes, although not discussed in this book, contributed to the influx of Caucasian, African American, Hispanic/Latino and East Asian migrants and immigrants from elsewhere in the United States and the world and were a critical factor in the history of housing in Los Angeles. At the end of the first decade of the twenty-first century, the stretch of East Fifty-ninth Place that would have been Goodyear Gardens was reviewed for potential preservation as a district notable for its contribution to the city's architectural, social and ethnic history of worker housing built to support Southern California's pre–World War II industrial economy.

NOTES

INTRODUCTION

1. McWilliams, *Southern California*, 234.
2. Huxley, *After Many a Summer*, 9.

PART I

3. Hutchinson, "Cure for Domestic Neglect," 168.
4. Ibid.
5. Hise, "Roots of Postwar Urban Region," 52.
6. *Los Angeles Times*, August 9, 1936.
7. Ibid., May 29, 1949.
8. Ibid., June 17, 1951.
9. Ibid., June 27, 1954.

PART II

10. *Los Angeles Times*, March 14, 1926.
11. Hise, *Magnetic Los Angeles*, 40.
12. *Los Angeles Times*, June 21, 1922.
13. Ibid., July 16, 1922.

14. Ibid., June 21, 1922.
15. Ibid., June 23, 1922.
16. Ibid., May 1, 1928.
17. Ibid., August 14, 1927.
18. Ibid., October 2, 1927.
19. Ibid., January 8, 1928.
20. Hise, *Magnetic Los Angeles*, 19.
21. Ibid., 17.
22. *Los Angeles Times*, September 16, 1928.
23. Ibid., September 8, 1928.
24. Ibid., January 19, 1929.
25. Ibid., January 12, 1929.
26. Ibid., February 1, 1930.
27. Ibid., March 28, 1930.

Part III

28. *Re: American Dream*, 5.
29. Ibid., 17.
30. *Los Angeles Times*, April 6, 1947.
31. Gebhard and Winter, *Architectural Guidebook*, 221.
32. Treffers, "Dingbat Apartment," 6, quoting Alan Hess's *Googie Redux*.
33. *Built in USA*, 56.

BIBLIOGRAPHY

Atchley, Margaret. *California Homes & Gardens.* Los Angeles: Wolfer Print Co., 1931.

Bauer, Catherine. *Modern Housing.* Boston: Houghton Mifflin, 1934.

Built in USA, 1932–1944. New York: Museum of Modern Art, 1944.

Castillo, Greg. *Cold War on the Home Front: The Soft Power of Midcentury Design.* Minneapolis: University of Minnesota Press, 2010.

Cuff, Dana. *The Provisional City: Los Angeles Stories of Architecture and Urbanism.* Cambridge, MA: MIT Press, 2000.

"Exhibition House Group, Los Angeles, California, Arranged by Miss Marie Louis Schmidt." *Architectural Forum* 65 (1936): 37–46.

Garden Apartments of Los Angeles: Historic Context Statement. Prepared by Architectural Resources Group for the Los Angeles Conservancy. Los Angeles, October 2012.

Gebhard, David, and Robert Winter. *An Architectural Guidebook to Los Angeles.* Rev. ed. Salt Lake City, UT: Gibbs Smith, 2003.

Gish, Todd Douglas. "Building Los Angeles: Urban Housing in the Suburban Metropolis, 1900–1936." PhD diss., University of Southern California, 2007.

Halbert, Blanche, ed. *The Better Homes Manual.* Chicago: University of Chicago Press, 1931.

Hise, Greg G. *Magnetic Los Angeles: Planning the Twentieth-Century Metropolis.* Baltimore, MD: Johns Hopkins University Press, 1997.

———. "The Roots of the Postwar Urban Region: Mass-Housing and Community Planning in California, 1920–1950." PhD diss., University of California–Berkeley, 1992.

Howard, Ebenezer. *To-Morrow: A Peaceful Path to Real Reform.* London: Routledge, 2003.

Hutchison, Janet. "The Cure for Domestic Neglect: Better Homes in America." *Perspectives in Vernacular Architecture* 2 (1986): 168–79.

Huxley, Aldous. *After Many a Summer Dies the Swan.* Mattituck, NY: American Reprint Co., 1976.

Los Angeles Times, various years.

McWilliams, Carey. *Southern California: An Island on the Land.* Santa Barbara, CA: Peregrine Smith, 1973.

Parson, Donald Craig. *Making a Better World: Public Housing, the Red Scare, and the Direction of Modern Los Angeles.* Minneapolis: University of Minnesota Press, 2005.

Polyzoides, Stefanos, Roger Sherwood and James Tice. *Courtyard Housing in Los Angeles.* 2nd ed. New York: Princeton Architectural Press, 1992.

Re: American Dream: Six Urban Housing Prototypes for Los Angeles. Princeton, NJ: Princeton Architectural Press, 1995.

Treffers, Steven Andrew. "The Dingbat Apartment: The Low-Rise Urbanization of Post-World War II Los Angeles, 1957–1964." Masters thesis, University of Southern California, 2012.

INDEX

A

Adams, Charles G. 26
Adams, George J. 69, 75, 76, 78
Adobe Electric House 57–58, 60
Architects' Building Material Exhibit 22–24
Arquitectonica 102

B

Barcume, Lyle Nelson 30
Barker Brothers 18, 24, 39, 42, 45, 52, 67, 68, 69, 71, 72, 74, 75, 76, 78, 80
Bashford, Katherine 42
Becket, Welton D. 33, 34, 35, 39, 40, 45, 106
Better Homes in America 21, 22, 24, 55, 59
Bissantz, Edgar 42, 43
Black, Milton J. 96, 97, 98
Bray, William M. 52
Bryan, Leland A. 87
Burns, Fritz B. 32, 33, 34, 38, 39, 40, 42
Burns, Silas R. 128, 129
Byers, John 26, 27, 29

C

California House and Garden Exhibition 10, 24–32, 25, 27
Cannell & Chaffin 26, 51, 52
Castles in the Woods 52, 53
Channel Heights 115, 116, 117, 118, 119, 121
Chesapeake-Rodeo Apartments 122, 123, 124, 126
Church, Thomas 115
Cliff Garten Studios 106
Coate, Roland E. 75, 76, 77
Compton Imperial. *See* Nickerson Gardens
Cornell, Ralph D. 26, 120
Crenshaw Village 14, 120, 121
Criz, Albert 52, 54, 122

D

Daniels, Mark 62, 63
Devereaux, Harley Ellis 106
Dorman, Richard 10, 11
Dreyfuss, Henry 36, 37

E

Eckbo, Garrett 33
Eckbo, Royston and Williams 122
England, Bert 51
Estep, Joe 26, 28, 29

F

Fairfax Park Apartments 121
Federal Housing Administration 25, 28, 29, 30, 31, 43, 110, 112, 119
Fifteen Group 111
Friedman, Milton M. 96, 97

G

Gibbs, C. Hugh 30
Gladstone, Harry 26, 52
Goetze, Siegfried 55

H

Hammer, Hiram J. 121
Heitschmidt, Earl T. 113, 114
Herding, Franz 66, 69, 75, 76, 78
Holler, Phillip 59
Hollypark Knolls 123, 124, 125, 126
House Beautiful 22, 23, 24, 55, 66, 67, 68, 69
House of Tomorrow 39, 40, 42, 43, 44
Hunter, Norman 52, 54
Hunt, Sumner P. 128, 129

J

Jerde Partnership 106
Johnson, Reginald D. 111, 112
John V. Mutlow Architects 108

K

Kaufmann, Gordon B. 26, 27, 29, 75
Kaufmann & Stanton 115
Kelley, H. Roy 23, 24, 27, 42
Kelly, Arthur 26, 28, 29
Kern, George 26

Kronish, Herbert 123
Kysor, Charles H. 88

L

Lee Callahan and Sons 91
Los Angeles Furniture Company 42

M

MacFarlane Partners 102
Maltzman, Max 15, 74, 75, 91, 92, 93, 94, 122, 123, 124, 125
Mar Vista Gardens 122
McDonald, Wallace F. 51
Menkins, A.W. 91
Meyer, Mendel 59
Modes and Manners 18, 19, 68, 69
Muir, Edla 26, 27, 28

N

Neff, Wallace 43
Neutra, Richard J. 15, 19, 25, 26, 28, 29, 33, 99, 106, 109, 115, 116, 117, 118, 119, 120
Newman Garrison + Partners 106
Nickerson Gardens 120, 121
Noonan, Frederick 88
Nutmeg House 39, 40

P

Page, Raymond E. 115
Parklabrea (Park Labrea and Park La Brea) 112, 113, 114, 115
Patrick Tighe Architecture 108
Peterson, Einar 76
Plummer, Charles 40
Post War House 32–40, 45
Powers, C.W. 89, 91

R

Risley, Winchton Leamon 26, 28, 30
Robertson, A. Manners 54
Rohde, Gilbert 42
Roulet, Henry de 86, 96

S

Sadler, Hammond 26, 110
Sailors, Patricia 46
Schmidt, Florence 23, 24, 26, 28, 31
Schmidt, Marie Louise 22, 23, 24, 25, 26, 28, 30, 31
Schultze, Leonard 113, 114, 115
Shoults, Tracy E. 56, 58
Siple, Allen G. 26, 29, 44, 45, 85
Smith, Ralph W. 51
Southlander 46, 47, 48
Spielman, Harold G. 42, 43
Starrett Bros. & Eiken 113, 115

T

Thedford, Shelley 54
Thiene, Paul 128, 130
Thomas, Seymour 26
Tomson, Tommy 113
Toor, Anita 26
Trout, Edward Hunstman 26

U

Urban Partners 102

V

Village Green 111, 112, 121

W

Watson, Loyall F. 110
Weaver, Martha 39, 45
Weber, Kem 18, 19, 42, 68
Weyl, Carl Jules 75, 76, 77
Whitmer, David J. 110
Wileman, Edgar Harrison 79, 80
Williams, Paul Revere 26, 28, 29, 52, 120, 121, 122
Wilson, Lewis Eugene 115
Wilson, Merrill & Alexander 112
Winsor, W.G. 39
W. & J. Sloane 47, 52, 53, 54
Woodruff, Sidney H. 56, 57, 60, 66
Wurdeman, Walter C. 33, 35, 39, 40, 45
Wyvernwood 110, 111

Y

Young, James C. 46

ABOUT THE AUTHOR

Ruth Wallach is a librarian at the University of Southern California and has written previously on the history of the built environment in Los Angeles.

Visit us at
www.historypress.net

This title is also available as an e-book